WITHAM
THROUGH TIME
John Palombi

AMBERLEY PUBLISHING

First published 2009

Amberley Publishing Plc
Cirencester Road, Chalford,
Stroud, Gloucestershire, GL6 8PE

www.amberley-books.com

Copyright © John Palombi, 2009

The right of John Palombi to be identified as the
Author of this work has been asserted in accordance
with the Copyrights, Designs and Patents Act 1988.

ISBN 978 1 84868 584 0

British Library Cataloguing in Publication Data.
A catalogue record for this book is available from
the British Library.

Typeset in 9.5pt on 12pt Celeste.
Typesetting by Amberley Publishing.
Printed in the UK.

Introduction

Although Witham was first recorded in the year 912, photographic records date only from the late nineteenth century. However, it was the decision by the post office in September 1894 to allow privately and commercially published cards to be sent through the post that led to many photographic records of the town in the form of postcards. This, combined with some personal collections, has given us an insight into life in Witham from the late nineteenth century onwards.

The town has changed greatly over this period, most significantly in the 1960s when it expanded to provide industrial estates, many new houses and a new shopping precinct. A bypass was also built at that time. The town has evolved to accommodate these changes and the purpose of this book is to identify and illustrate them.

The original Saxon settlement of Chipping Hill still has a medieval appearance, with many buildings from the fourteenth century onwards remaining, including the fourteenth-century church. We can see few changes in the landscape around Chipping Hill Green, but at the other end of the spectrum we can see that the entrances to the town from the north and south have changed considerably. The main High Street, known as Newland Street after its establishment by the Knights Templar in 1212 as 'Newland', also has a significant number of ancient buildings. However, many of the buildings were refronted in the eighteenth century when Witham became a fashionable 'spa town'. This gave a Georgian feel to the architecture although medieval timber frames remain hidden behind some of the façades.

Transport has, of course, changed over this period. Witham Railway Station is the junction of the former Great Eastern Railway main line where the Braintree and Maldon branch lines diverge. The Maldon branch line was closed in 1966, but the Braintree branch was saved from the 'Beeching axe' and was electrified to provide through trains to London from 1977, the main line having been electrified in

the 1960s. The station was rebuilt in 1907 after the horrific wreck of the *Cromer Express* in 1905 but it has changed very little since then, and we can see photographs from the Great Eastern Railway era alongside modern pictures that show few differences. We can also see the changes in road transport from the horse and carts of the late nineteenth century to the early motor vehicles of the twentieth century and on to the cars and buses of today.

Altogether we have comparisons of Witham life over a period of nigh on 150 years described in photographs from around 1860 to 2009. You will see that life has got busier, more cluttered and more crowded over time as the town has moved from being a small East Anglian market town to a busy centre with local industry that also acts as a dormitory for London commuters.

Present residents and those who work in the town will recognise street scenes and will be fascinated by how the town looked many years ago. It will also be of interest to those who have long since left the town and would like to see how it has coped with the beginning of the twenty-first century.

Dedication

Witham and Countryside Society WCCS

This book is dedicated to the Witham & Countryside Society. This society aims to: encourage high standards of architecture and planning; stimulate public interest and pride in the environment; and promote the conservation, development and improvement of public amenity and historical interest.

With thanks to the society members who made their postcard and photograph collections available and to the committee members who helped in its preparation. All royalties will go to the Witham & Countryside Society.

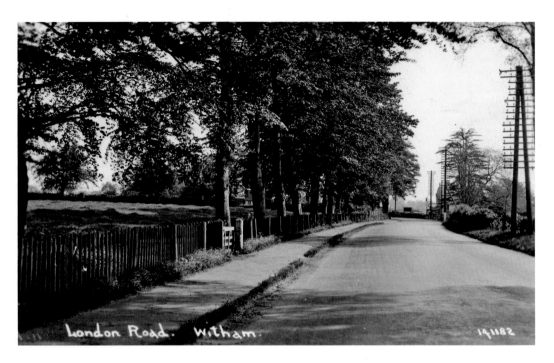

Hatfield Road

The main road into Witham from London is now known as Hatfield Road. On the left coming into the town was Witham Lodge, a fine house now demolished. The grounds have been replaced by an estate and an access road, and the sign for the junction with Maltings Lane. On that corner is the Jack & Jenny public house with its Dutch gables just showing in both pictures. It has only been a public house since the 1970s.

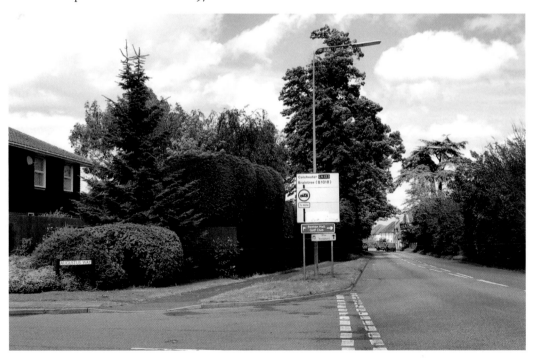

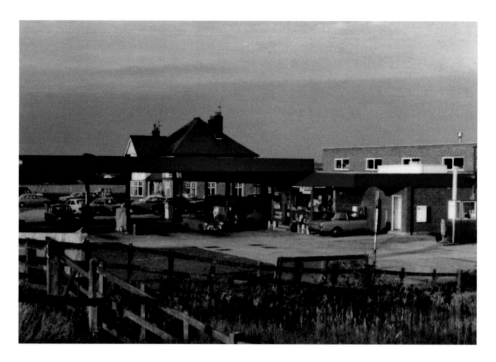

Lynfield Motors

A café on what was then the A12 London to Great Yarmouth trunk road has now developed into a major service station with a convenience store and a large petrol filling station. Over recent years it has been the site of some major car dealerships and vehicle hire services. It is conveniently close to the busy A12, which now bypasses the town.

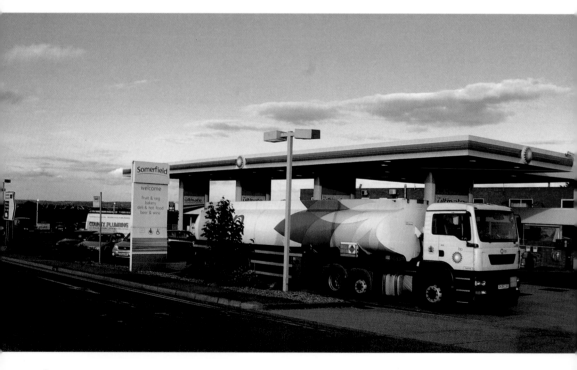

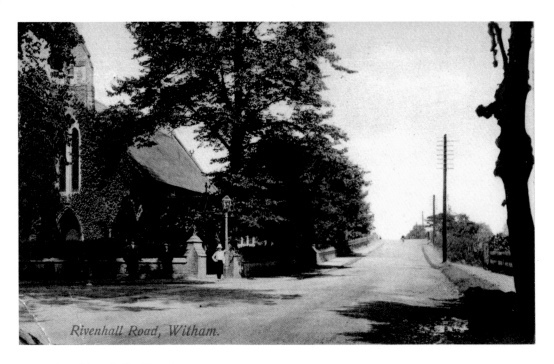

Rivenhall Road, Witham.

The Old Catholic Church

These views along Colchester Road show the old Catholic church when still in use and then later after being converted into a private residence. This took place after the Catholic congregation moved to the church in Guithavon Street in 1989 (see page 56). The road rises to the bridge over what was once the Maldon branch railway line but which now forms a footpath.

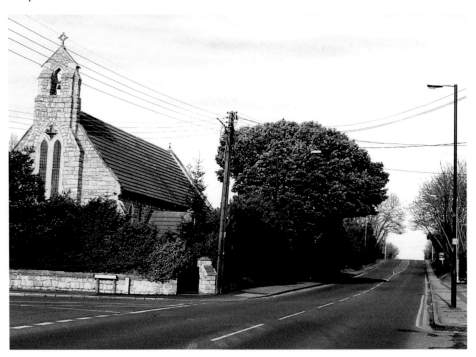

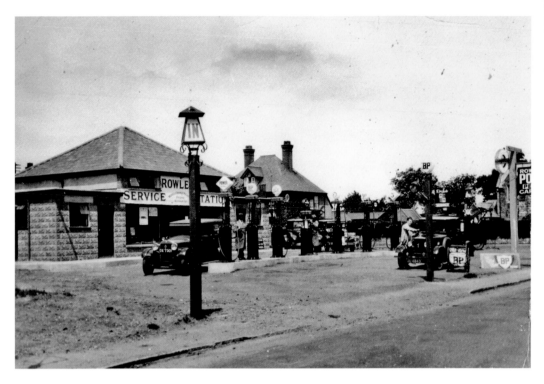

Grove Garage

The Grove Garage, shown here in 1932, was then known as Rowleys Service Station. It later became Hurrell & Beardwell and is now Markham & Smith. It can be seen that the site has been completely redeveloped and upgraded by the addition of a car sales showroom.

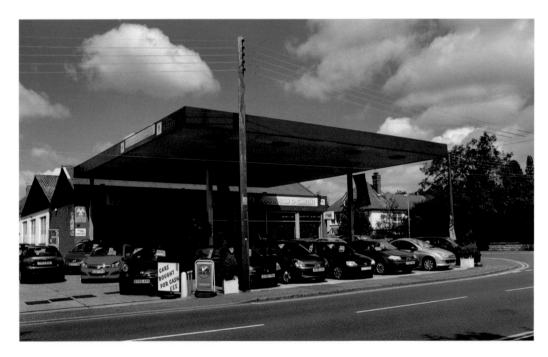

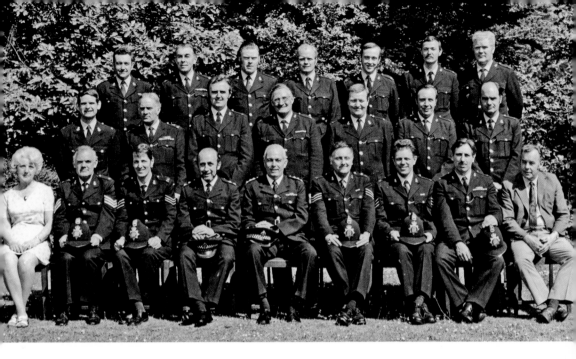

Witham's Law Enforcers

Witham Sub-Division, 1975, Back Row: Constables: B. Lincoln, D. Wilson, N. Wright, D. Jepson, D. Lewis, R. Napier, A. Arrowsmith. Centre: Constables: L. Jennings, L. Carter, A. Conerney, D. Smith, T. Fisher, R. Waller, B. Marples. Front: Mrs Love (Civilian Clerk), Sergeants D. Rothero, M. Ashton, Inspector J. Page, Chief Inspector R. Shayshutt, Sergeants Williams and R. Wager, Constable E. Cummings, Detective Constable R. Marshall.

In 2009, from the left: Sergeants Mark Wilson and Wayne Norcott, PCSOs Daniel Seymour and Michelle Eaton, Police Constable Adam Greenaway, Inspector Mick Pitcher, PCSO Rosie Kinman and Police Constable John Hallworth.

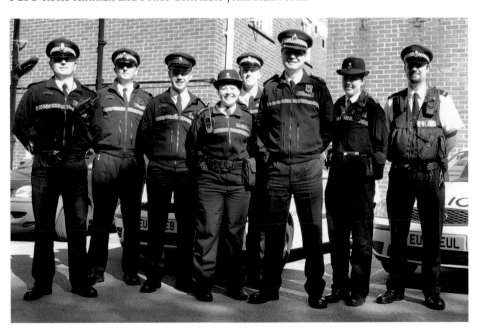

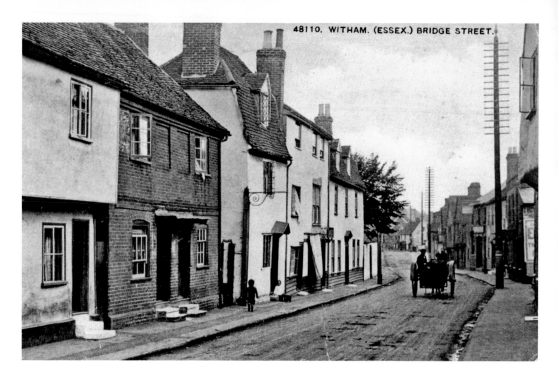

Bridge Street

Looking down towards the river and town centre in the early twentieth century and early twenty-first century. The central point just before the bend on the left is Bridge House with two dormers. Buildings on the left have been demolished and replaced with Bridge Street Motorcycles, but some properties on the right are recognisable today.

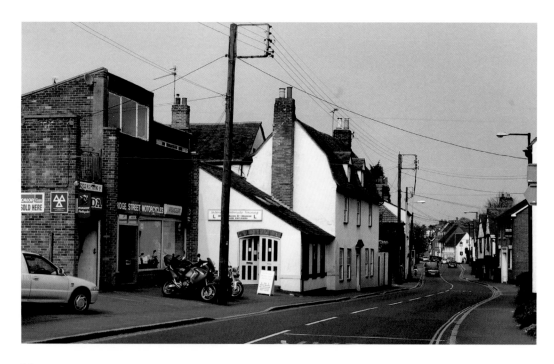

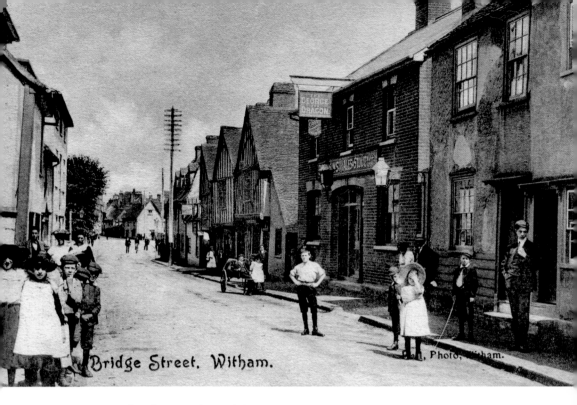

Bridge Street. Witham.

...en, Photo, ...tham.

Some Post-Medieval Properties and the George & Dragon

Pictured are properties in Bridge Street in close-up. The George & Dragon, on the right, was closed as a public house in the 1970s and is now a business centre, and the Morning Star further down is now a nursing home. In between are three houses (now two dwellings) dating from the sixteenth century that have changed very little over the centuries.

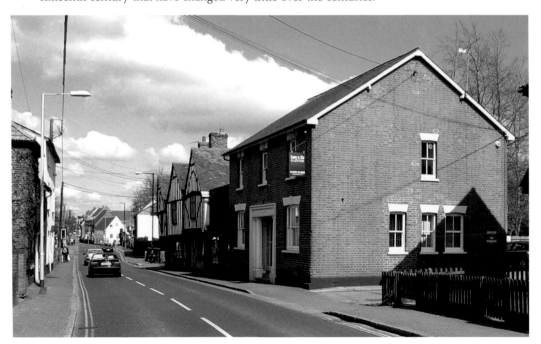

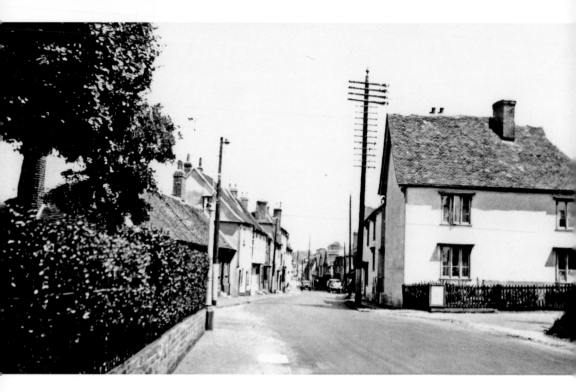

Bridge Street Junction

This is the junction of Bridge Street, Spinks Lane, Howbridge Road and Hatfield Road with a gap of over half a century. In the older picture Bridge House can be seen with the almshouses close to the junction on the left. The right-hand corner is now the RAFA Club, and the roadway has been widened for modern traffic.

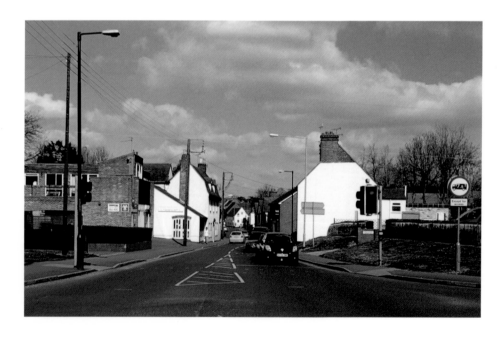

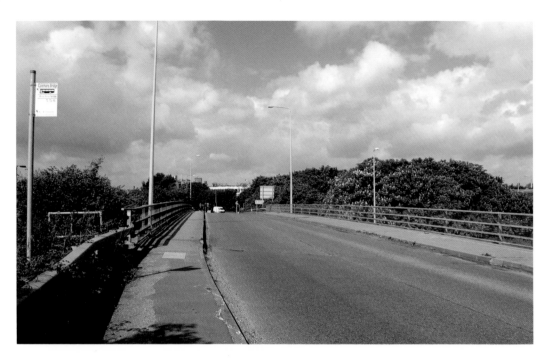

The Witham bypass at Coleman's Bridge

Witham bypass was constructed in the 1960s to relieve the serious congestion that had blighted Witham for many years. This view at Coleman's Bridge, the junction with the old road at the Colchester end of town, is shown just after construction in the late 1960s. A treeless landscape with the Station Maltings clearly visible, together with the gasometer which then stood next to the Maldon branch line, contrasts with today's view.

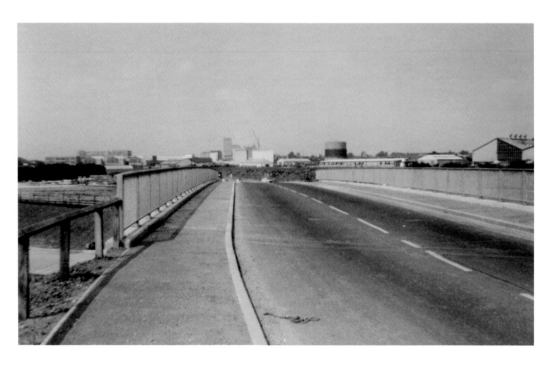

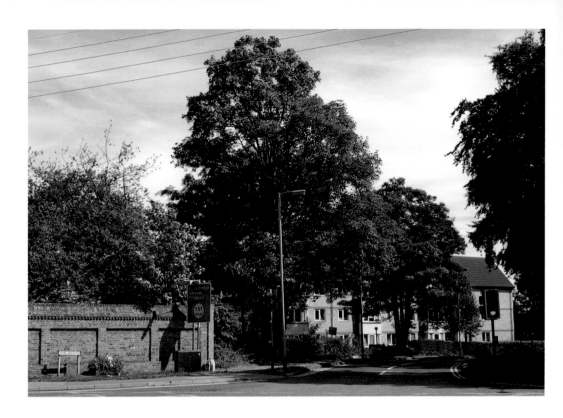

The Grove House

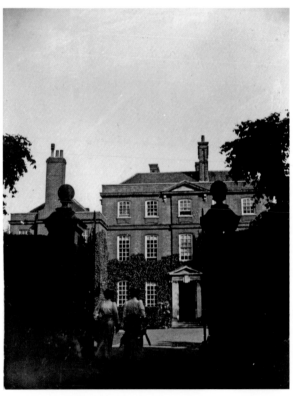

This junction where The Avenue and The Grove meet Newland Street stands on the site of a magnificent mansion known as The Grove. Built around 1696 but empty from 1921 when the then owner died, the house was dismantled in 1932. An opening was made in the wall (and the remainder fully restored) to gain access to the new development around 1970. Two ladies entering the grounds around 1900 contrast with a typical street scene in 2009.

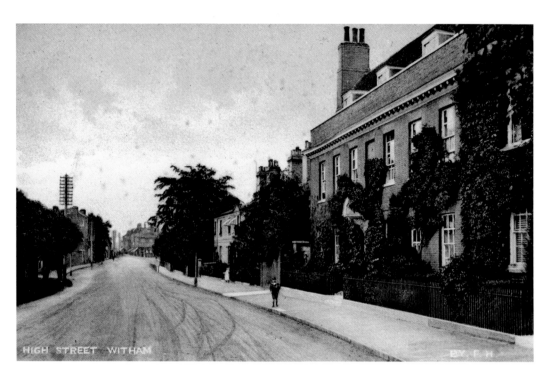

Avenue House

Looking along Newland Street towards The George the scene has changed little. Avenue House, on the right, remains intact and so does the terrace beyond, but the other side of the road shows some thinning of the trees and some new development.

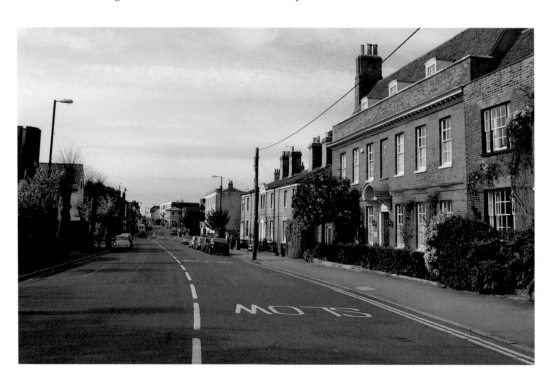

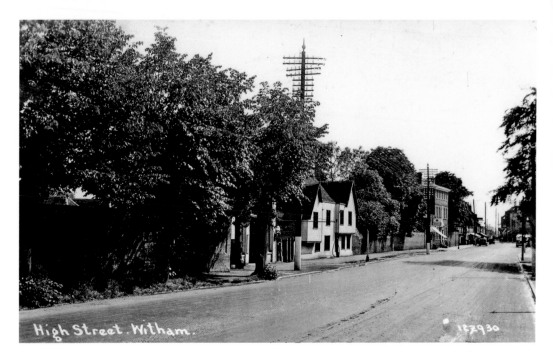

Freebournes Farmhouse

The earlier view shows only Freebournes Farmhouse and High House surrounded by trees. Freebournes Farm remained a working farm until 1967. It was converted to shops in 1975 and by 2009 these included the Asian Inn, a take-away food outlet. Note also High House, then a three-storey building but reduced in height in the 1930s. It was Cook's Pork Butcher from 1929 to 1937 and is now Lian, a Chinese restaurant.

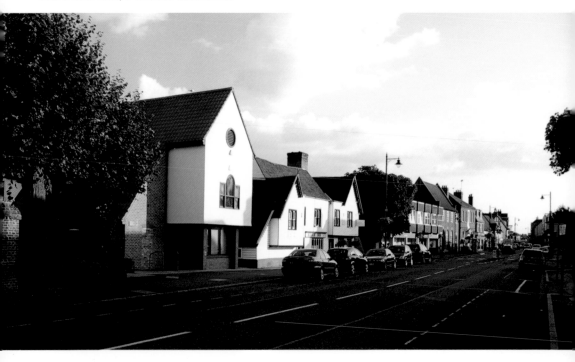

Whitehall, Freebourne's Farm and Avenue House

A hand-tinted postcard of a view looking towards Colchester. Whitehall, on the extreme left, was a private house until 1905 and from then until the start of the First World War a private school for boys. During that war soldiers were billeted there. The earlier picture appears to have been taken around this period. It is now the library (see page 18).

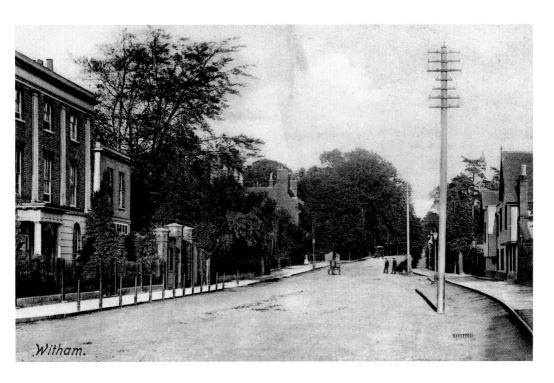

Witham.

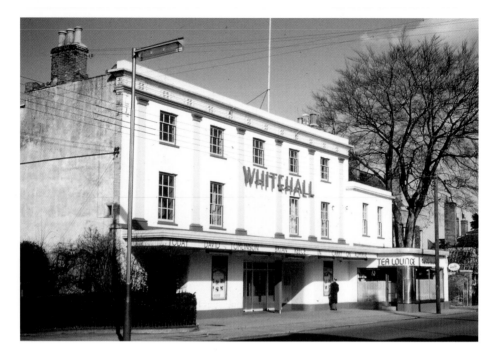

Whitehall

The Whitehall Cinema, in its heyday, was the centre of entertainment. It was converted into a cinema in 1926, with an auditorium built behind, after standing empty after the end of the First World War. The cinema finally closed in 1964 and became virtually derelict until it was bought by the County Council and converted into the library, which opened in 1981.

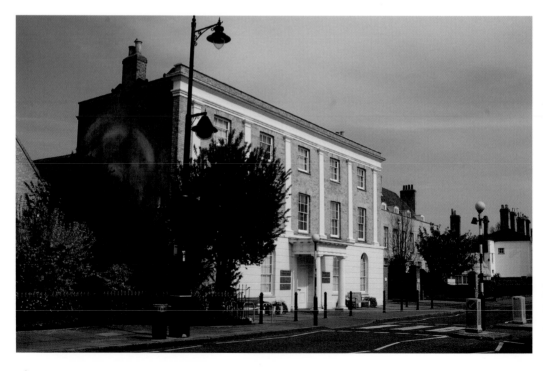

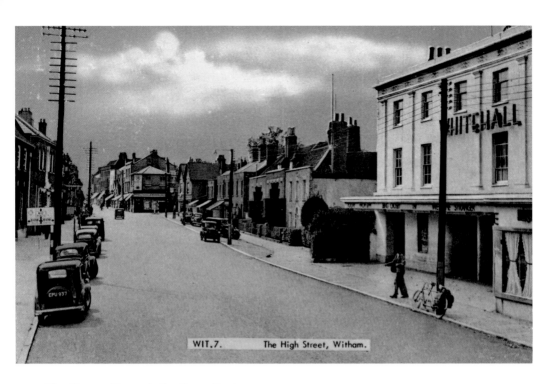

WIT.7. The High Street, Witham.

The Cinema Towards the Town Centre

Very little has changed between the times of these photographs. The postcard of the 1950s shows a street already becoming full of cars and the A12 — then running through the town — is clearly shown by the street sign. Just the addition of a zebra crossing completes the street scene of today.

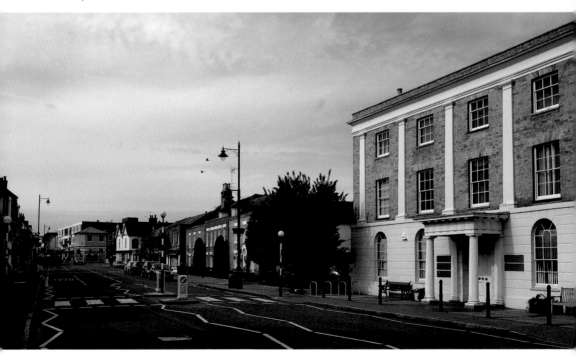

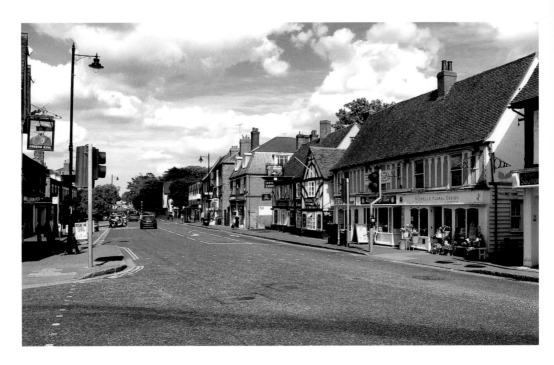

The Red Lion

Newland Street, viewed from the traffic lights at Collingwood Road and looking towards Colchester, shows the Red Lion without its decorative timber around 1900 and High House behind. The scene in 2009 is much more cluttered and High House (behind the new addition with dormer windows) is reduced to two storeys. Next door was Rowe, a hairdresser, which is now Reid's Sandwiches, and what was then a residence has become Rizzi's Café. Nearest the camera J. C. Green, greengrocer, is now Michelle, a florist.

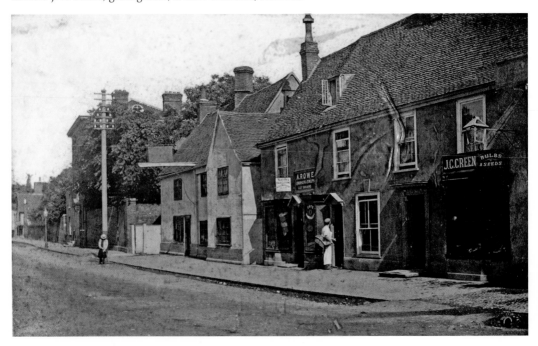

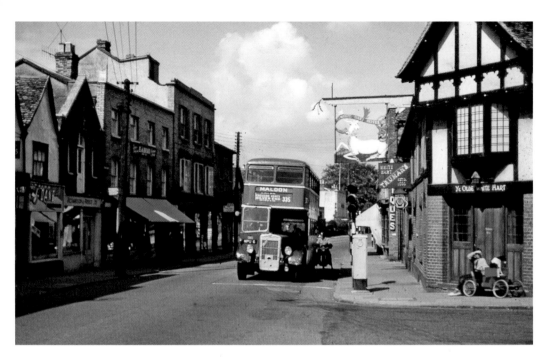

Junction of Newland Street and Maldon Road

We start with a 1960s view of the Maldon bus, service 335, passing the White Hart Hotel. Note the child with a kart and dog in front of the pub doors on the corner. The bus was Eastern National Omnibus Co. Bristol K5G with E.C.W. L55R body, No. 1284. The 2009 counterpart is a Stephensons service 38 with an Optare Solo No. 325 passing a much more decorated White Hart with the 1960s-built Newlands Precinct opposite.

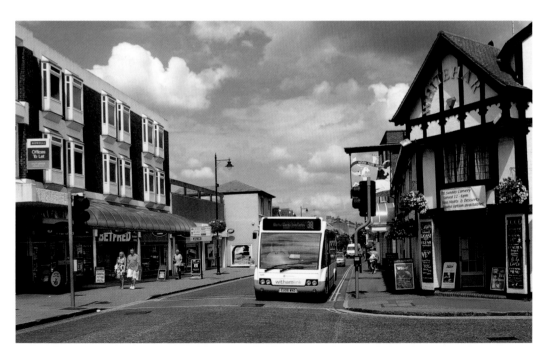

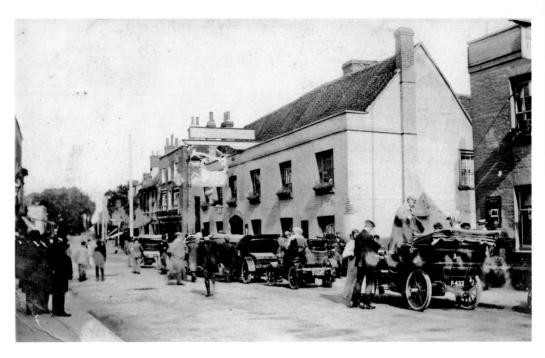

The White Hart

This view of the front of the White Hart is unusual in that the early photograph shows a great deal of traffic while the modern equivalent is almost car free. The Edwardian scene is certainly very busy, while in its modern equivalent parking outside is prohibited. The notices on the walls have proliferated.

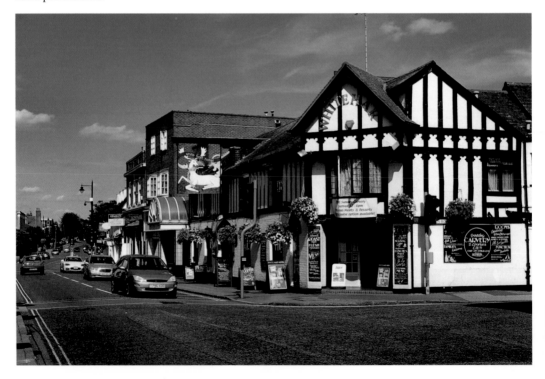

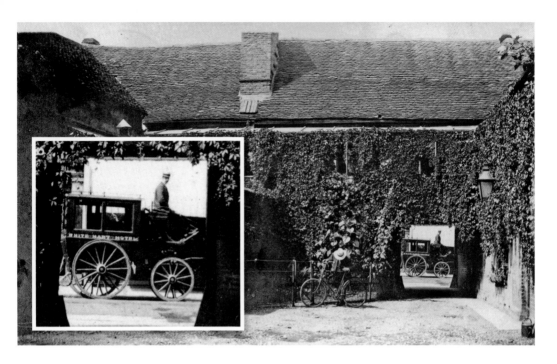

The White Hart Yard

The White Hart is one of the old Witham coaching inns. There was an entrance to the coach yard through the building, now glazed and incorporated into the ground floor. Through the yard entrance is a carriage with the name of the inn on its side (see insert). The old entrance is now hidden behind modern additions, the latest being the smokers' shelter on the left.

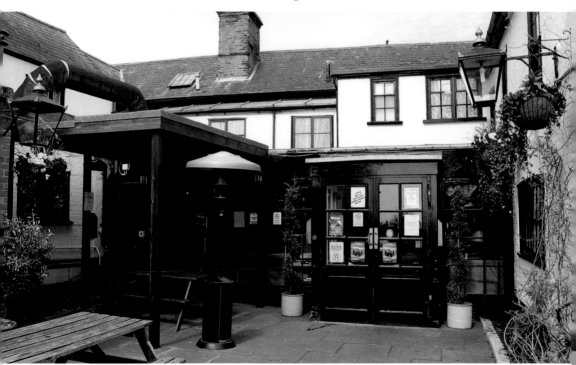

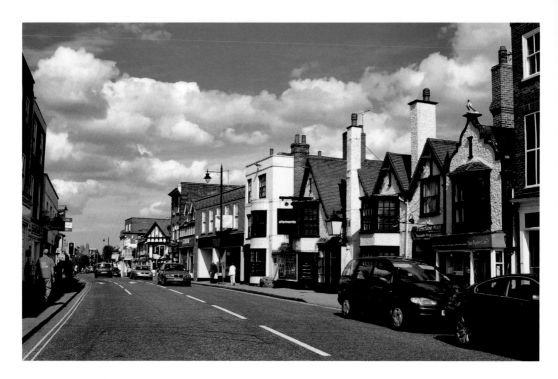

The Spread Eagle

With over a hundred years separating these pictures, there have been a number of changes, mainly in the middle distance. While the Spread Eagle itself (now renamed 'elements') is relatively unchanged, as is the building to the extreme right, the White Hart has a new corner. Closer to the camera, The Angel and International Tea Company have gone and are replaced by Central Buildings and two newer buildings.

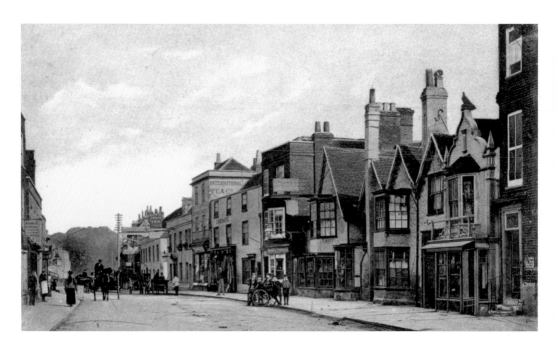

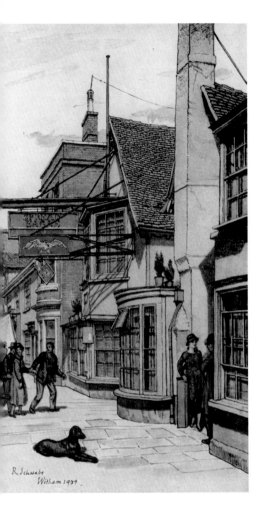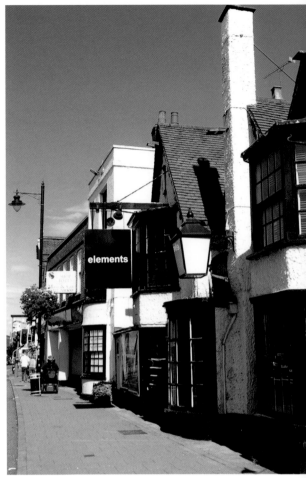

The Spread Eagle
This print of the Spread Eagle, dated 1934, depicts a family scene outside the hotel. The building is now a nightclub called elements and has lost most of its 'old world' charm despite being structurally still relatively intact.

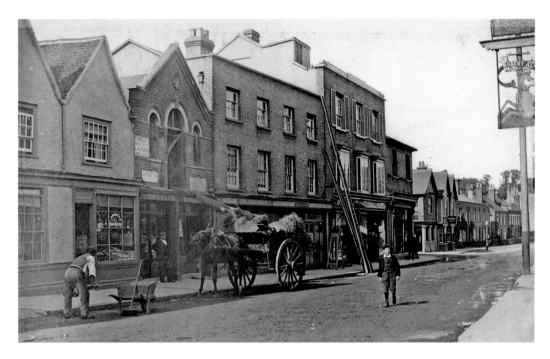

The Town Centre *c.* 1900

Here we can see the town centre shops where the Newlands Precinct (completed in 1968) now stands. The shops were, from the left, George Alma Gage, hairdresser and tobacconist, Charles Brown, corn merchant (loading a cart), Eleazar Edwards draper and Edward Spurge draper and grocer. Today they are the Precinct, Martins the newsagent, Betfred betting shop, Celebration Cards and Boots.

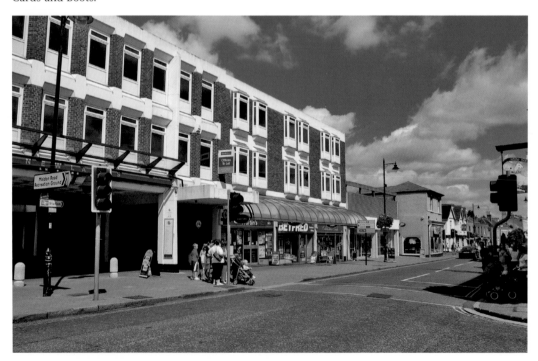

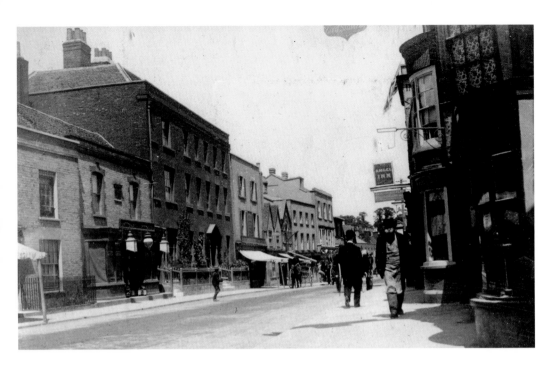

The Newlands Precinct

From this low viewpoint by elements, the Newlands Precinct stands in its incongruous glory — a classic 1960s architectural and planning mistake now very difficult to rectify. What a shame it was not built behind the façade of The Wilderness, the large three-storey Georgian-fronted house it replaced. The ground floor of The Wilderness was converted into shops in 1928-29.

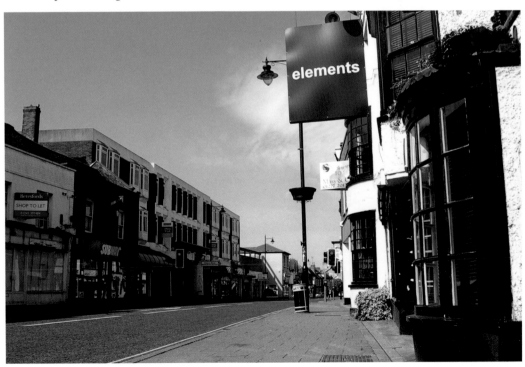

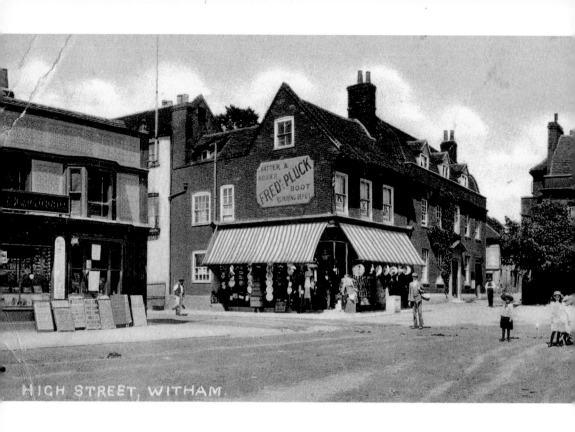

HIGH STREET, WITHAM.

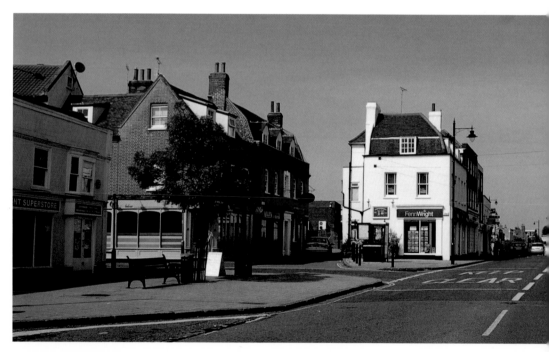

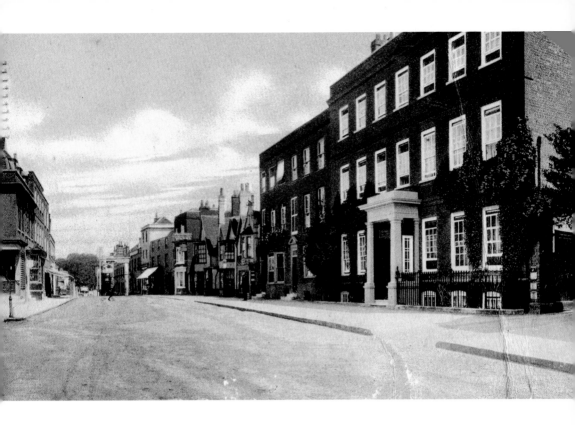

A Panoramic View of the Town Centre

From just before the First World War, on the left was
Bernard C. Afford, printer and stationer. After 140 years
as a stationer this building became a discount store
in 2004. On the opposite corner of Guithavon Street
was Frederick Pluck, a tailor. After suffering serious
structural failures the building was demolished in 1999,
but it was rebuilt and opened again in 2001 looking
very much like its predecessor, this time as a bar and
restaurant.

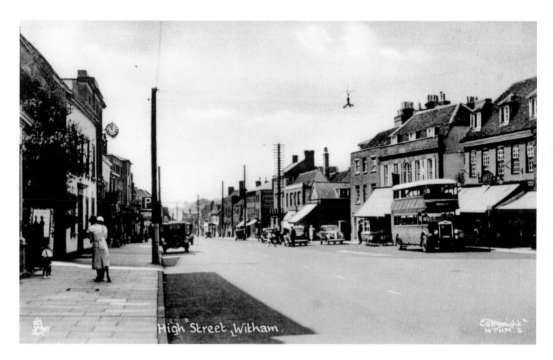

High Street, Witham.

The Central Area of Newland Street and Bus Stop

Soon after the Second World War a Hicks Bros. Leyland TD1 (with a rear open staircase) was probably *en route* to Braintree, while in 2009 a Blackwater Link Dennis Dart with a Plaxton Pointer body stops on route 90 for Ebenezer Close. Behind the bus stop was E. Davies, tailor and outfitter, now occupied by the Helen Rollason charity shop, while a little further down was Wilfred J. Marshall Bicycle Sales, which is now McColl's newsagents incorporating the post office.

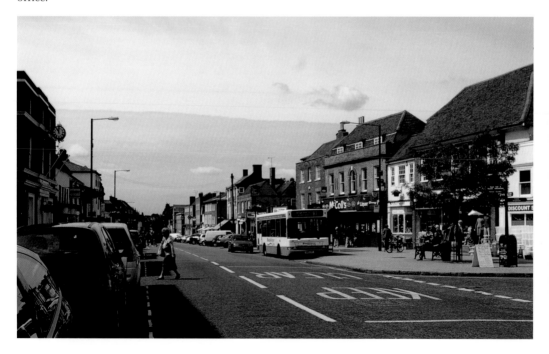

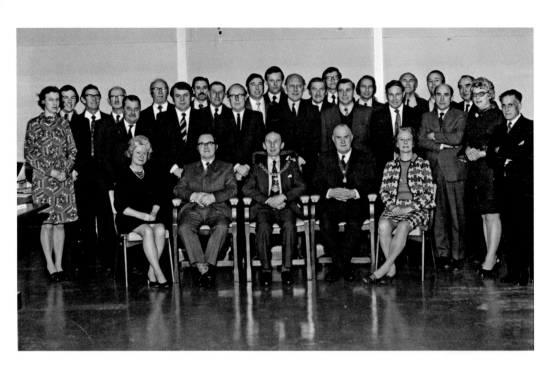

Witham's Elected Representatives

Witham Urban District Council members in March 1974 just before Witham was absorbed into Braintree District Council. Front row seated (left to right): Mrs J. M. Lyon, (3rd) S. E. Smith, R. C. Bartlett, J.P., Miss K. M. Richards. Second Row standing (left to right): Mrs H. Pitchforth, W. A. Marsh, J. R. F. Keeling, J. E. B. Gyford, R. V. C. Brown, D. K. Willett, D. M. Clampin, (9th) Mrs J. B. Reekie, A. J. Bentley. Back Row, standing (left to right): (3rd) R. A. Scollan, H. Metcalf, (6th) A. E. Moss, J.P., D. G. Upson, P. M. Ryland, (10th) Reverend J. J. J. Barrett, A. W. White, R, Berry.

Right: some Witham Town Councillors outside the town hall in September 2009, from the left: Town Mayor Barry Fleet, Steve Hicks, Lucy Barlow, John Goodman, Paul Heath and Nick Scales.

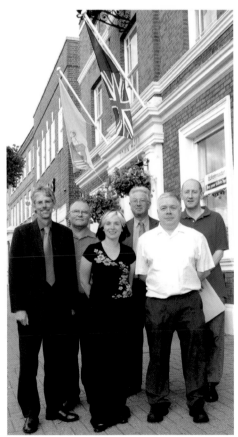

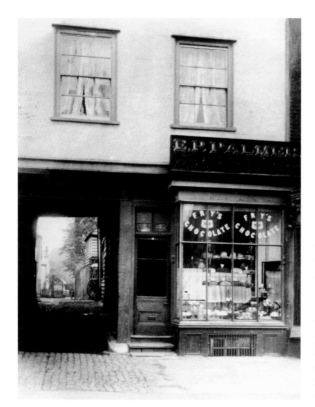

Palmer's Shop and Brush Yard
This shop fronting Brush Yard (through the arch) was a watchmaker's until 1896, but from 1902 it was a bakery. Edward Philip Palmer was the baker from 1922 until 1957 when Edward T. Gilbert took over. It remained a bakery until Edward retired in 1989. It then lay empty until 1997 when a florist took it over for a few years. It became an estate agency in 2001.

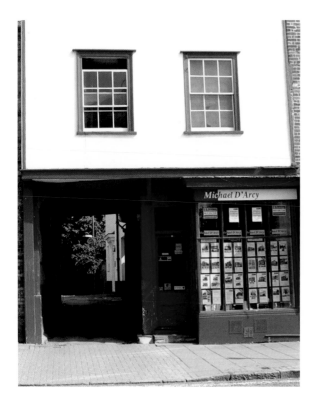

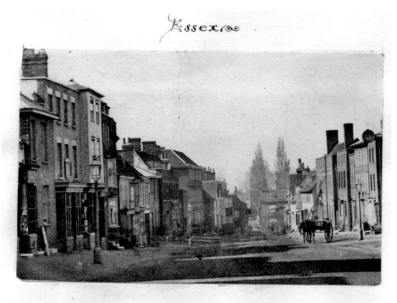

Essex

High Street. Witham.

The Lower High Street

This is possibly the oldest photograph of Witham, an albumen print dated about 1860. The midday sun has cast long shadows so it would be winter. The present-day equivalent, also taken at midday but in the summer, has less shadow. Many buildings on both sides of the road are still identifiable, and the street scene generally is the same although, of course, it is now much busier.

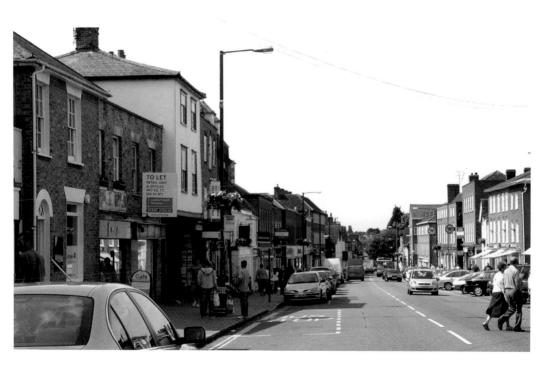

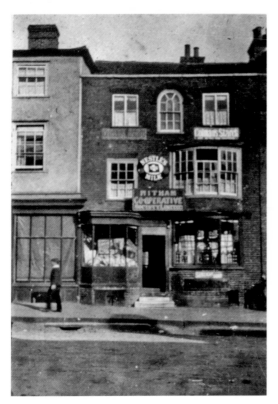

No. 85 Newland Street

This building first became a shop in the mid-nineteenth century, and in 1853 the post and telegraph office moved here and stayed until 1887. Then the Witham Co-operative Society opened their very first shop here, selling groceries. Ten years later it became a watchmaker's. In 1950 it became E. King & Son, watchmaker's and jeweller's shop. By 1990 the business had been taken over by the Goldsmith Group who continued to trade under the name King until 1995. It was then that the shop was re-opened as the Jewellery Store, a branch of the Co-op, so after a hundred years it became a Co-op again! In 2009 Four Seasons gift shop moved in.

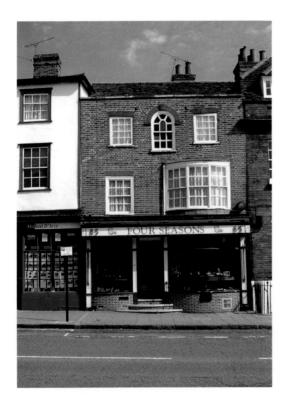

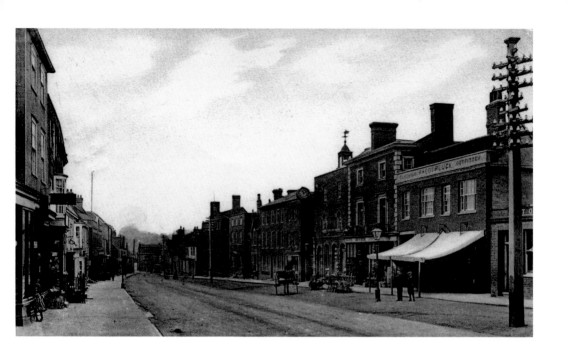

The Old Constitutional Club

The gap between Holt's shop and Byford's on the right is now the entrance to the United Reformed church, but the earlier postcard shows the Old Constitutional Club, which burned down in 1910. A new Constitutional Club was built in Collingwood Road in 1914.

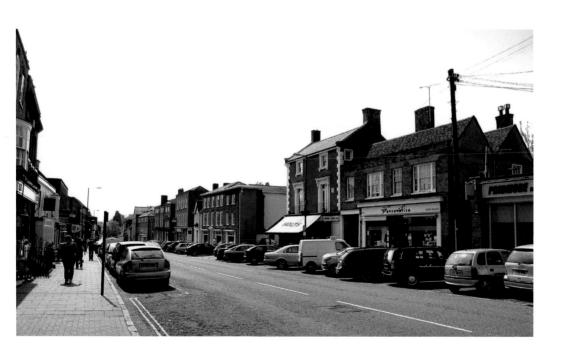

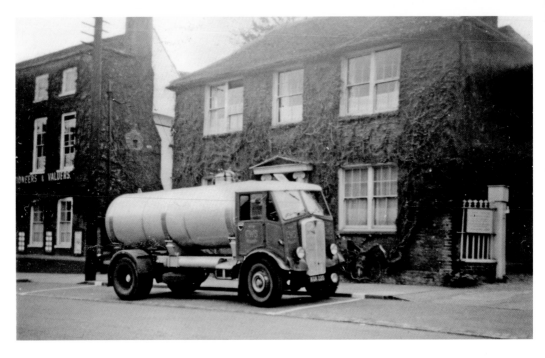

Christmas House

In the earlier photograph, next to Batsford Court, stood Christmas House, a predecessor of the present building. A Co-operative Society milk tanker is parked outside. It was in about 1970 that Christmas House was demolished and the present building, now occupied by Farleigh Hospice charity shop and the Nationwide Building Society, was built on the site. Before 1978 Batsford Court next door was Balch & Balch, an estate agent's and valuer's.

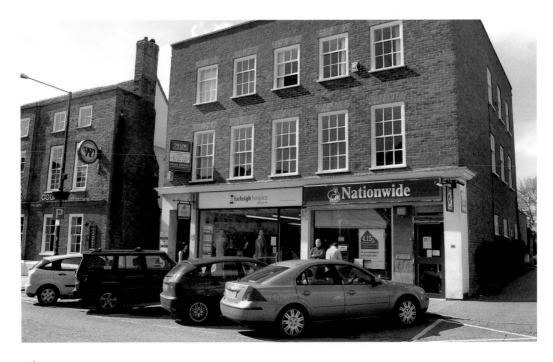

Central Buildings

Pictured is London Central Meat Company's shop, which was in Central Buildings from 1927 to 1948. It then became Gallant's Outdoor and Camping shop, which remained until 1996. The Children's Society charity shop took over until 1997, then Bits miscellaneous goods until 1998. Then came Scope, another charity shop until 1999 and finally Rag, Tag and Bobtail, haberdasher. And after all these changes the original 'LCM Co. Ltd' can still be seen in tiles at the shop entrance.

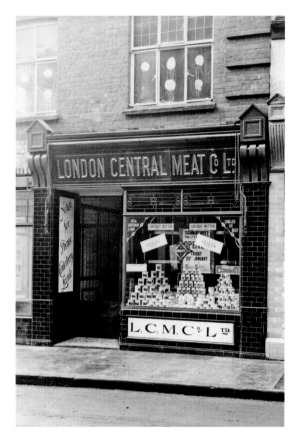

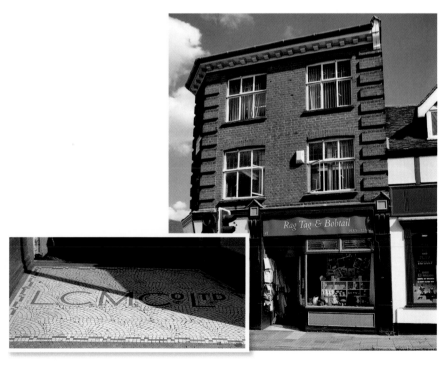

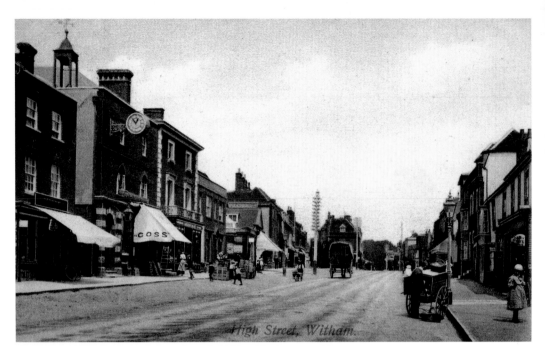

The Familiar View of the High Street Entering Witham from London

On the left, with the town clock projecting from the wall, stood the Constitutional Club, with the Coker & Rice, cabinet makers shop front on the ground floor. The building also housed the Literary Institute, founded in 1844. After the Constitutional Club was destroyed by fire in February 1910 the site became the forecourt of the United Reformed church.

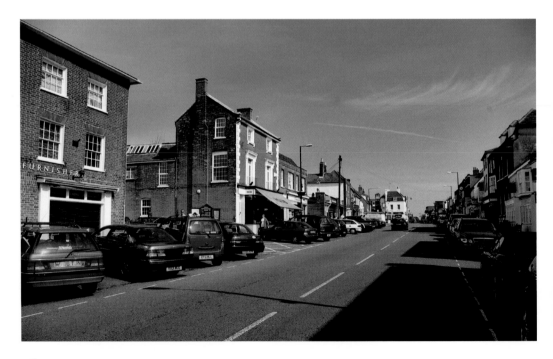

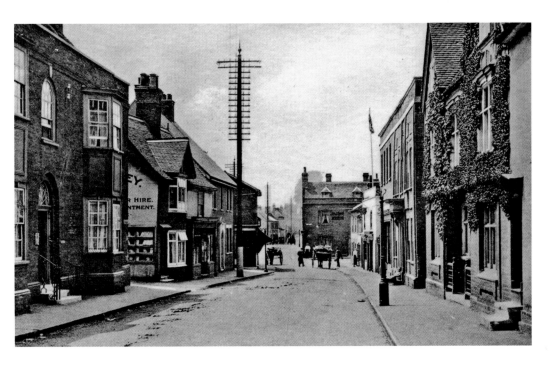

The Town Surgery

Fern House, on the left, has been a doctor's since before 1900. Across the passage was William Ardley, a bakery until about 1930 followed by a boot repair shop, a ladieswear shop, a chemist's and, since 1985, a betting shop. On the right was a school run by William and then Frederick Mann until about 1900. It became Borno's, a chemist's, in 1983. In the centre of the picture is the old gas works, cleared to make a car park in the 1960s.

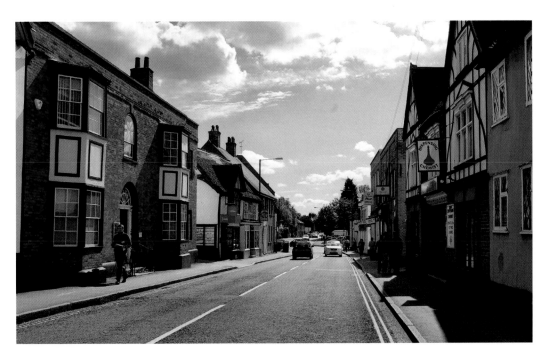

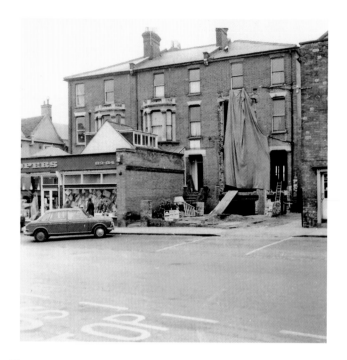

Medina Villas

When Medina Villas were built in 1883 the land in front of them was a garden. Shops were built in front around 1887, 1894, and the last, seen here under construction, in 1971. The post office until 1939 and Westminster Bank from around 1961-1968 occupied the shop on the far left. Coopers took both shops from 1968 to 1998. The last shop, seen here under construction in February 1971, has been Mellons Soft Furnishing ever since.

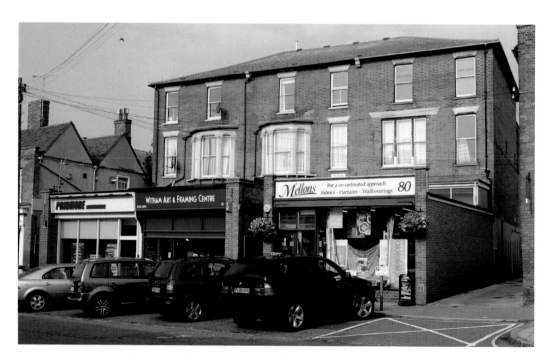

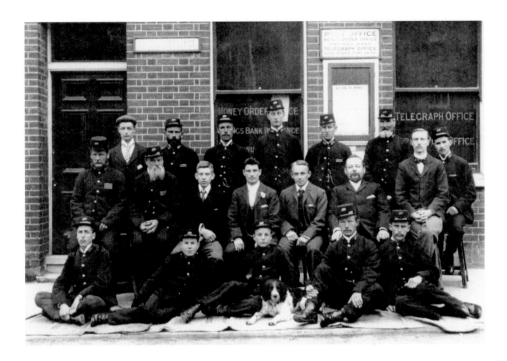

Witham's Post Office Staff

The post and telegraph office staff in the early twentieth century. The post office stood where Pridmore, the betting shop, is now until moving to a new building opposite the present library in 1939. The present members of staff were photographed at the main sub-post office now located at the back of McColls. From the left: Tina Carter, Rosemary McCreary, Andrea Brewer, Piush Vaidya (manager), Pat Duckmanton, Jade Williams and Julia Easton.

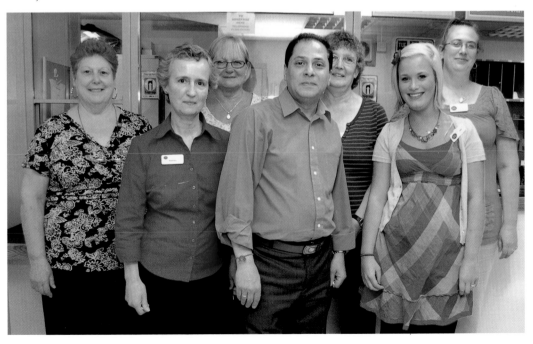

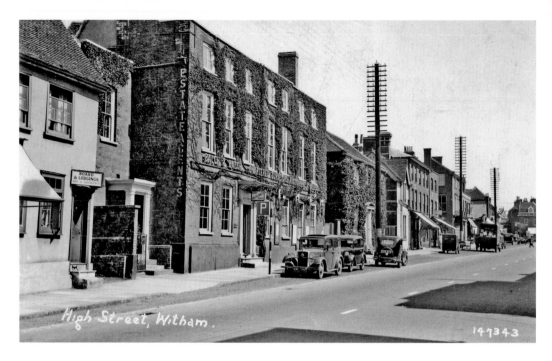

The Batsford Court

This prominent building in the High Street was Balch & Balch, chartered surveyors, auctioneers and valuers who had been the occupiers from the early 1920s to the late 1970s. The building became a hotel in 1980 and then the public house shown in the later view in 2002.

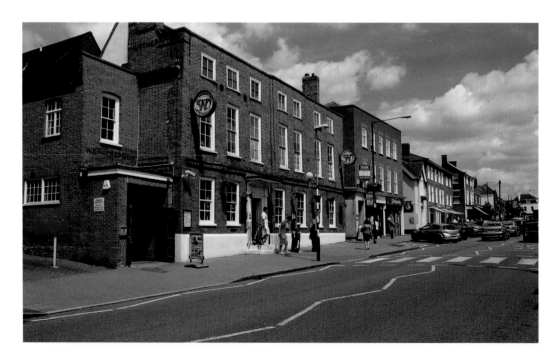

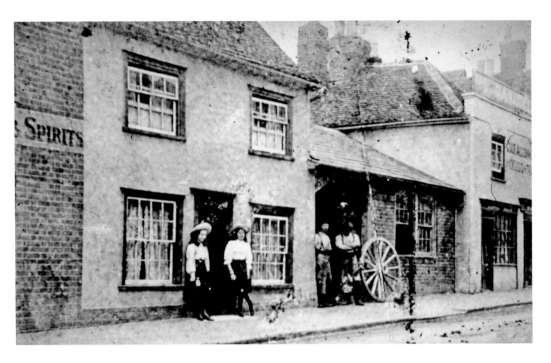

The Old Newland Street Forge

Squeezed between the Crotchet and the Globe Inn was a blacksmith's forge. The Crotchet was originally the taproom of the Blue Posts Inn but when the inn closed in the mid-1800s its taproom remained open as the Spotted Dog. It was renamed the Crotchet in about 1900 and remained so until 1996. After some more name changes, including Jermyn's, CM8 and Bojangles, it became the Spice Destiny Indian restaurant in 2008 and the Silver Lotus Chinese restaurant in 2009.

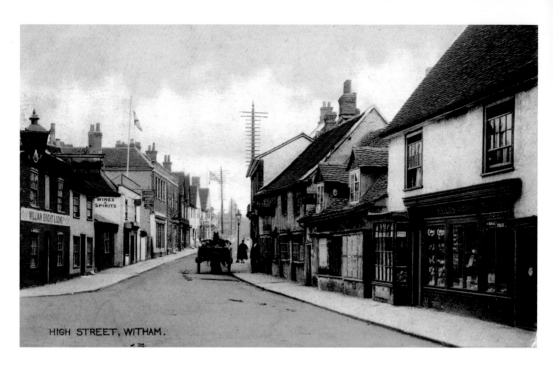

HIGH STREET, WITHAM.

From Mill Lane Towards the Town Centre *c.* 1900

The Globe Inn on the left closed down around 1914. It was next occupied by many small businesses before opening as AJM Glass in 1982. Further up was Blue Posts Inn, and after that closed in about 1845 the Garrett family moved in as china and glass dealers and tailors. In about 1929 Ernest Coates took it over as a bicycle and radio shop, and his son Reginald continued to run it as an electrical shop until its closure in 1994. In 1997 it opened as Four Seasons gift shop.

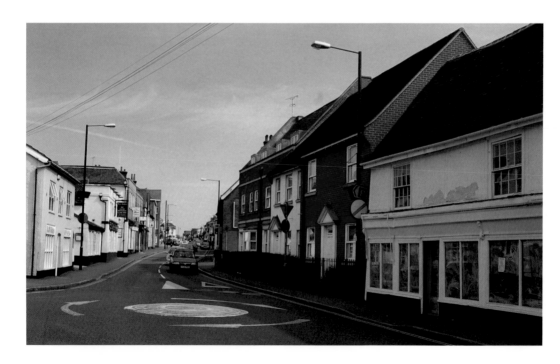

From Mill Lane Towards the Town Centre *c.* 1960

The same view as on the page opposite but this time showing an empty site hidden behind a corrugated iron fence, before Barnfield Place was built in 1994. Among its previous occupants were Glovers Brothers first bicycle shop and a block of three shops, among them a baker's and a boot and shoe repairer's. These were all demolished at about the time of the Second World War.

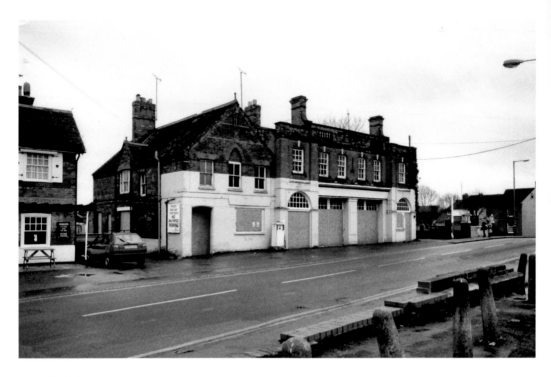

West End Garage

This is a very early example of a building specifically for the motor trade, built for Glover Brothers Motors in about 1911. Between about 1960 and 1988 it was used for the manufacture of Ginetta Sports Cars. After this all the associated buildings were demolished leaving only the original structure. It is now offices called, appropriately, Ginetta House.

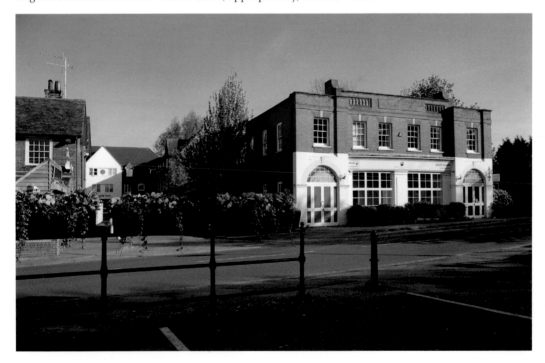

Mill Road,
Witham.

Mill Lane and the River Walk

The River Walk runs right through Witham, and where it adjoins Mill Lane there have been some changes over the years. The older view shows a terrace of cottages with Hollybank House on the right behind the hedgerow. By 2009 Bramston View has replaced the cottages and Hollybank is a quiet development of mainly bungalows.

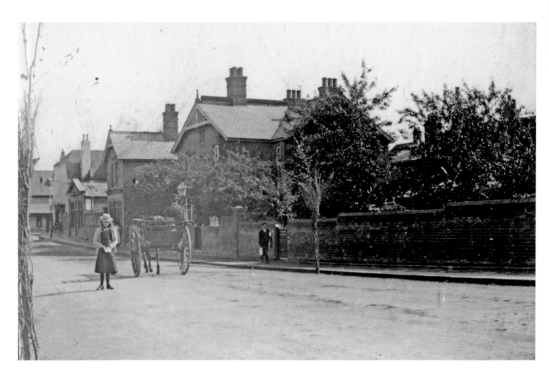

Collingwood Road — South Side

Two properties are prominent in both of these two views of the Newland Street end of Collingwood Road. The *c.* 1900 photograph shows a rather forlorn girl in the middle of the road, a more dangerous place now. Some demolition in the 1960s made space for a car park on the right, which is used for a market on Saturday mornings.

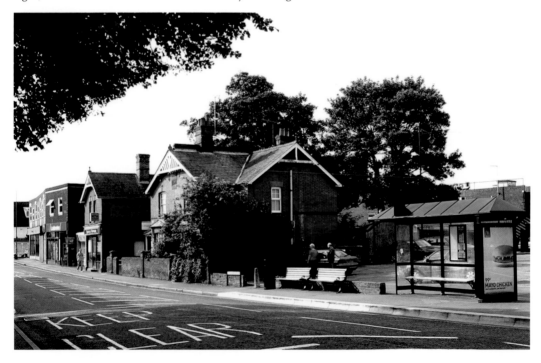

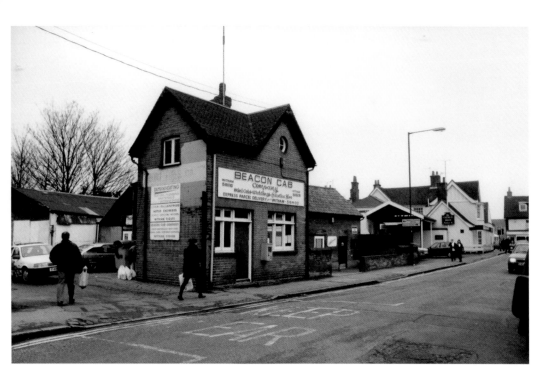

Collingwood Road — North Side

The prominent building in this 1980s view is the Beacon Cab Company with a tyre-fitting business behind. The scene now is of Ben Sainty Court, a new row of houses named after a hero of the 1905 *Cromer Express* disaster at Witham Railway Station.

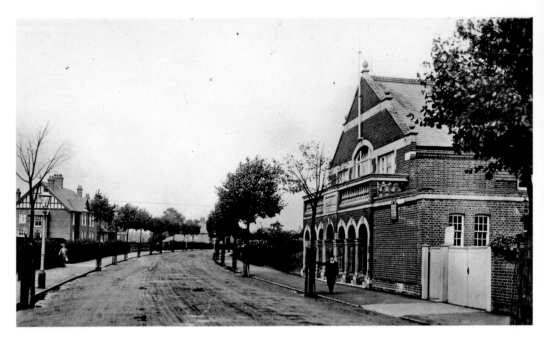

The Public Hall

At the town end of Collingwood Road, the Public Hall was built in 1894 and has altered mainly by the entrance arches being filled in. There has been further development on the other side of the road towards the railway station.

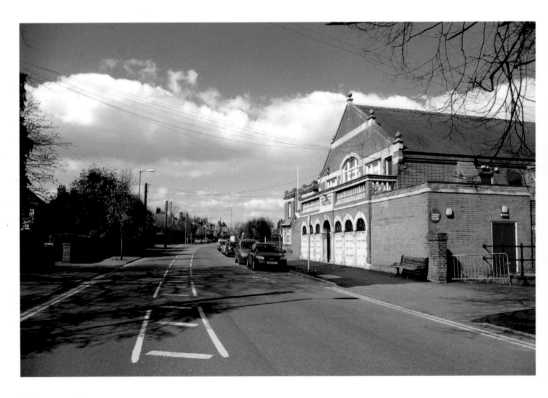

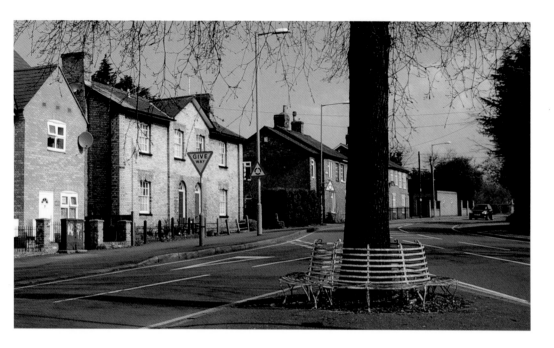

The Jubilee Oak

At the top of Collingwood Road, at the junction with Guithavon Valley, stands the Jubilee Oak planted to commemorate Queen Victoria's golden jubilee in 1887. Apart from some modern in-filling, the mainly nineteenth-century houses have changed little. The oak has become larger but the seat remains intact.

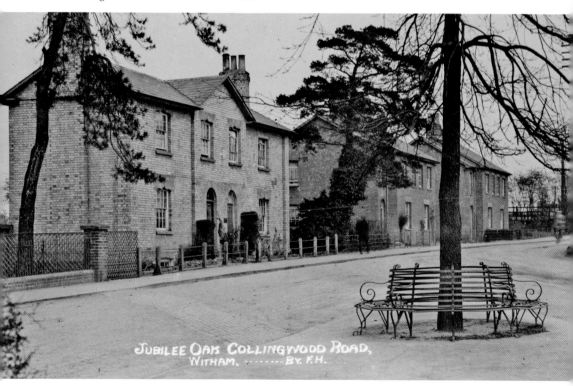

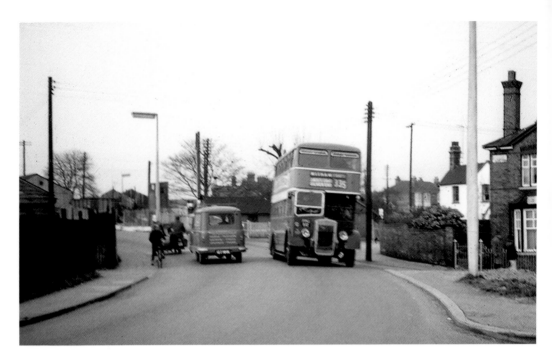

The Railway Bridge

Another bus view, which shows very similar transport to the views on page 21. This time Stephensons Optare Solo No. 326 works the 38 service following the footsteps (or tyre treads) of an Eastern National service 335 for Maldon with another Bristol K5G with E.C.W. L55R body. This bus is accompanied by other typical 1960s transport over the bridge before it was widened later in the 1960s.

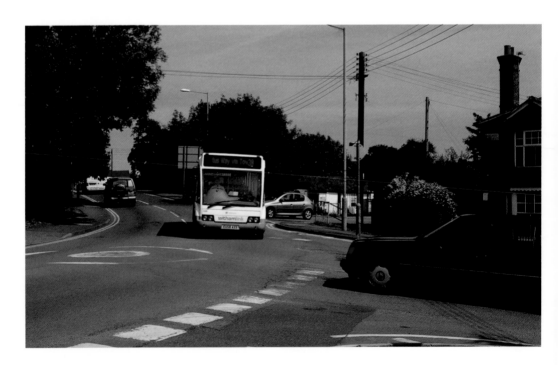

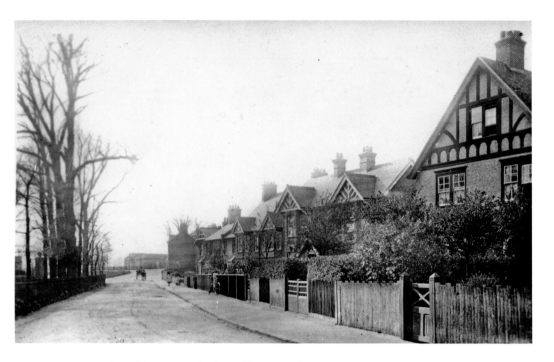

Avenue Road Looking Towards the Railway Station
The buildings here have changed very little over the years, but in the distance the earlier view shows the cattle market building in Collingwood Road, while the later view has Sherbourne House, a much newer office block. On the extreme left of the earlier view can be seen the gatepost of The Avenue (see page 55), which has since been hidden by hedgerows and the building now on this side of the junction.

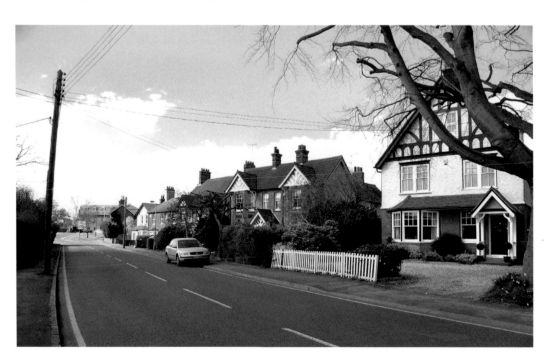

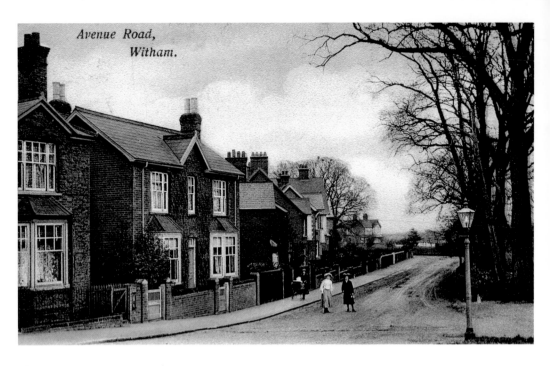

*Avenue Road,
Witham.*

The Avenue to Avenue Road
This view along Avenue Road from The Avenue shows Avenue Villas and the original track from Chipping Hill to the Colchester Road. Street lighting and layout have changed but the buildings remain the same.

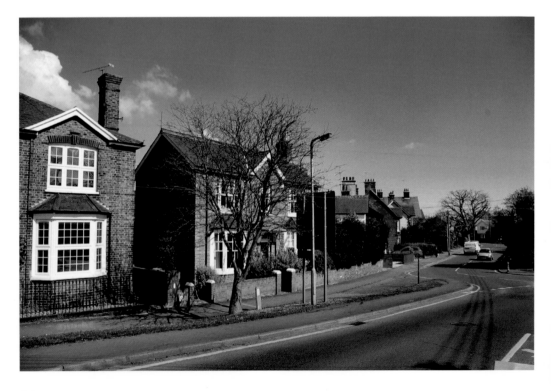

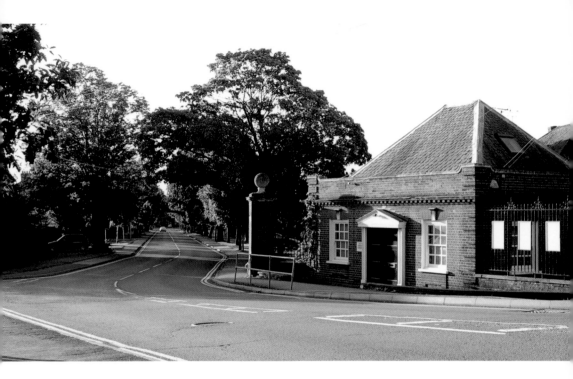

Avenue Lodge and The Avenue

The Lodge and one gatepost marks the spot for the two views separated by the best part of a century, the housing seen in the later photograph dating from the 1920-30s. The avenue was laid out as a driveway for The Grove (see page 14), the front door of which can just be seen in the distance in the earlier photograph.

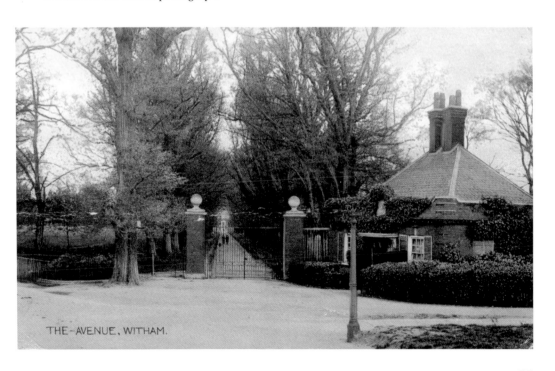

THE-AVENUE, WITHAM.

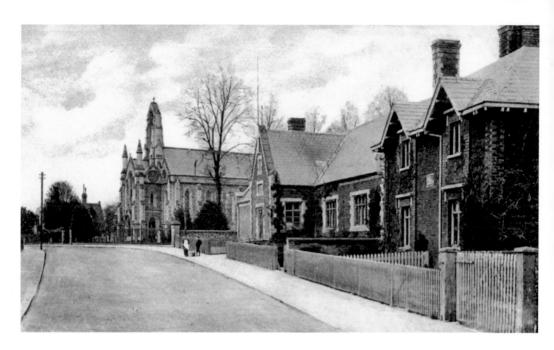

The National School and All Saints' Church, Guithavon Street
All Saints' church, Church School and cottages around 1900 shown in an Afford postcard. The church, after lying derelict for a number of years, was restored by the Catholic congregation and re-consecrated in 1989. The school and cottages have been replaced by a car park where a brave attempt has been made to improve the appearance with flower troughs.

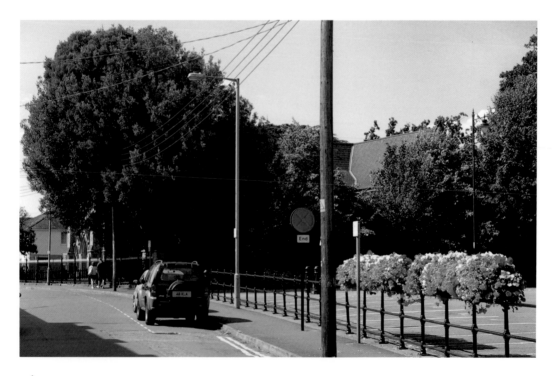

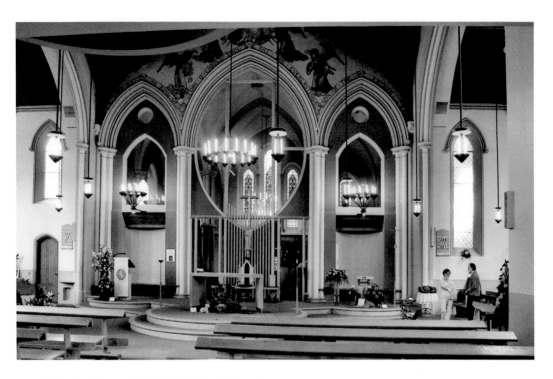

Holy Family and All Saints' Church Interior

The postcard of the original interior shows wall paintings, pews and some magnificent organ pipes. The later view, taken on 20 June 2009 during the annual Flower Festival, shows that the wall paintings have survived but the seating and organ have been replaced. A mezzanine floor has also been added, just visible at the top left of the picture.

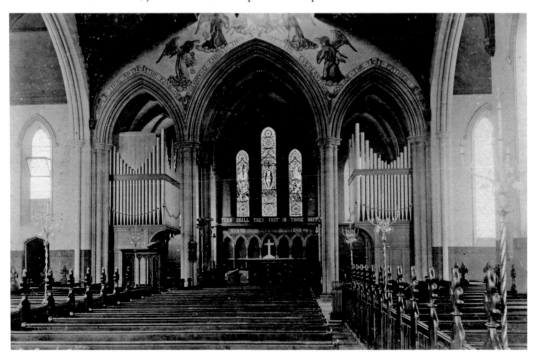

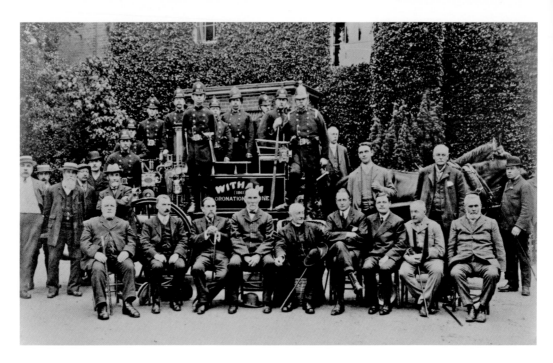

Witham's Fire Fighters

A new steam-pumped fire engine was handed over on Wednesday 28 June 1911 to Philip Hutley, Chairman of Witham UDC. In 1964 the crew are photographed outside the Fire Station in the yard behind The Swan. In the back row, from the left: Percy Adams, George Wright, Vic Wood, Tony Williamson, Ray Ashby, Kenny Stoneham, Dick Cowel, Peter Smith, Fred Coote, Roy Adams. In the front row, from the left: Roy Cranmer, Kieran Boylan, Roger Emmens, David Thorogood, Bill Thorogood, John Rushen, Fred Elliot.

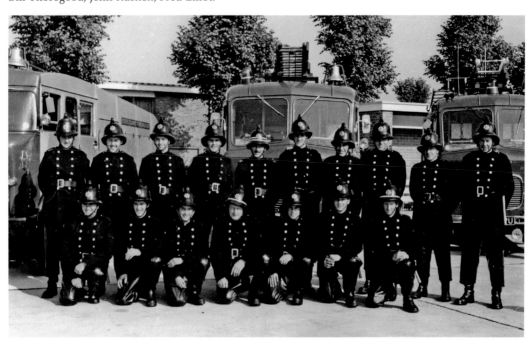

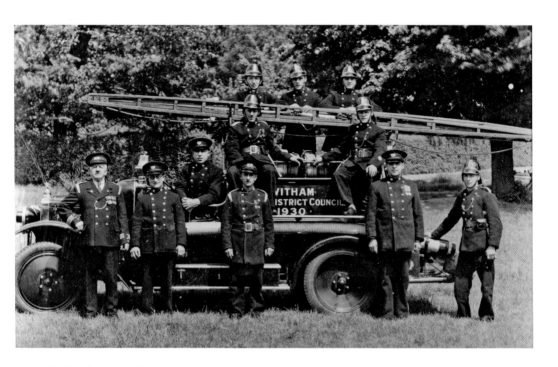

Witham's Fire Fighters

In November 1930 the town received its first motorised engine, seen here probably in the field opposite the old fire station in Guithavon Street. A modern fire station was completed in Hatfield Road on 24 September 1966. In the yard at the rear in August 2009 are, from left to right: Jack Bayford, Wilf Mathieson, Steve Chapman, Rob Purdue, Terry Hutton, Peter Perrin, Dave Westwood, Andy Lindop, Andy Mott, Andy Heath, Stuart Moore, Rob Cork, Adrian Richardson and Andy Moore.

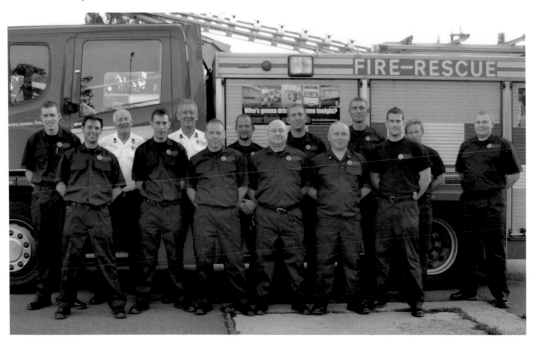

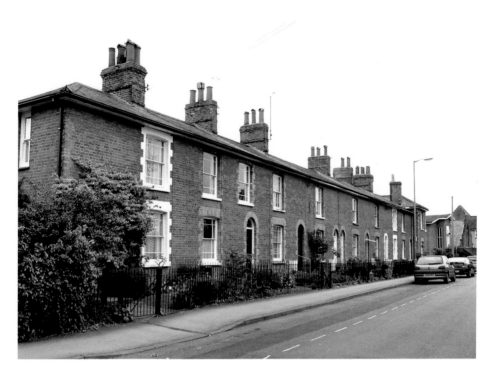

All Saints Terrace

Again in Guithavon Street about 1900 is a terrace of Victorian cottages dating from 1861. They have survived remarkably well and form an attractive background to the street scene. On the extreme right is the original Methodist church separated from the terrace by a row of almshouses.

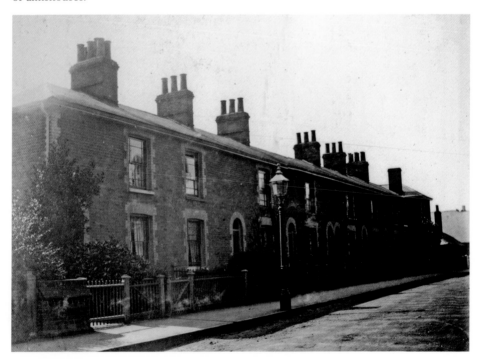

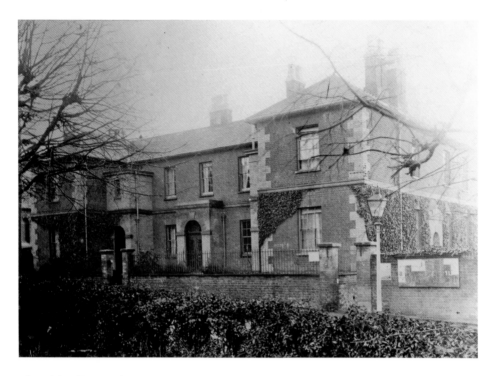

The Old Police Station

Witham's old police station in Guithavon Street closed in 1937 when the police moved to the new police station in Newland Street. The old station then became the first base for the Essex Police Driver Training School. It was demolished in the 1980s and replaced by Mill Vale Lodge.

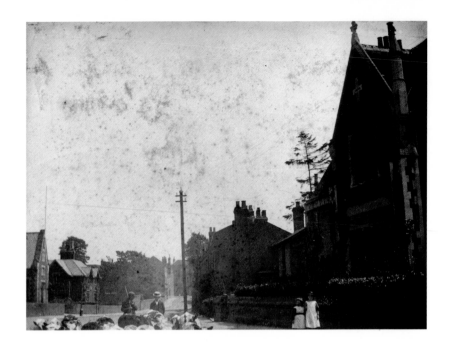

Cattle in Guithavon Street

Cattle are herded down Guithavon Street in about 1900, probably destined for the abattoir that was behind the school and cottages on the left. The building on the right, once a savings bank but now offices, has survived largely intact. However, there have been many changes further up on the left-hand side and it is a long time since cattle were seen in any Witham street.

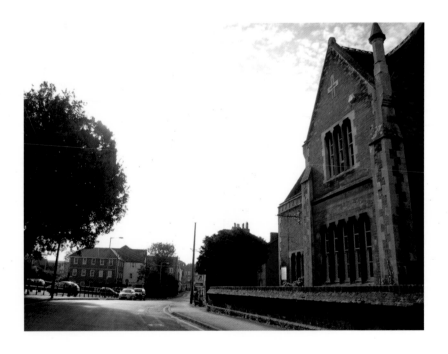

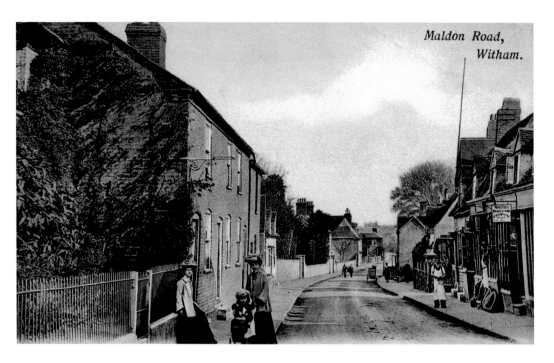

Maldon Road

There is not so much to recognise between these two views of Maldon Road, looking away from the town centre. The white building on the left with the two dormer windows, now Crofters Brasserie, can be seen in both views but there is little else to identify in this old hand-tinted postcard.

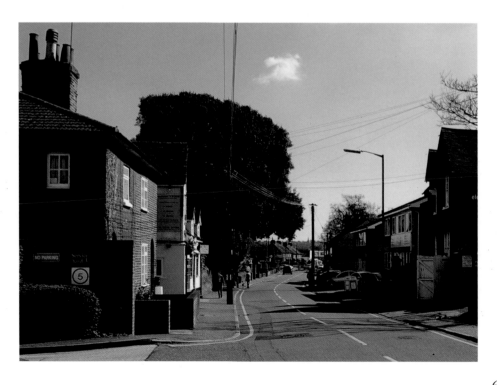

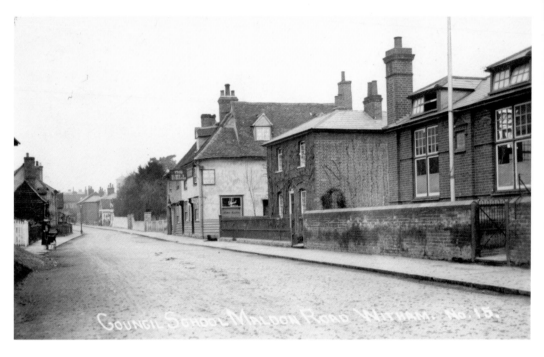

Witham Board School and School House

The school on the right and the schoolhouse next to it was a Witham Board School until the mid-1960s and is now Parkside Youth Centre. Just past the schoolhouse in the earlier view was the Bell public house. Park Stores now stands on the site.

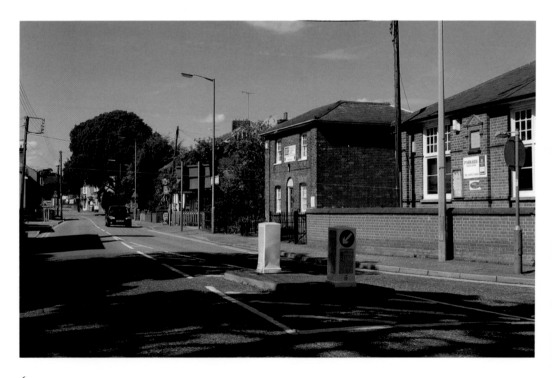

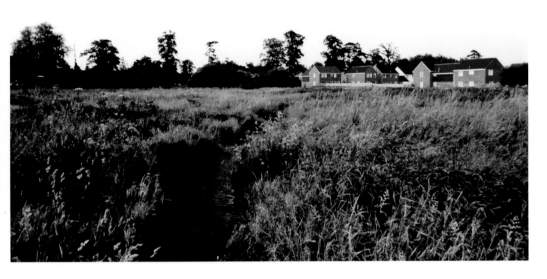

The Grove Centre and Housing Estate

The Grove Centre shopping precinct, which leads to the Tesco store, was opened in 1988. Prior to this it was open fields. The houses on the Grove Estate were started in the early 1970s, and the early view shows houses completed in 1981. Most of that view is now a car park with The Grove link road adjacent to the houses.

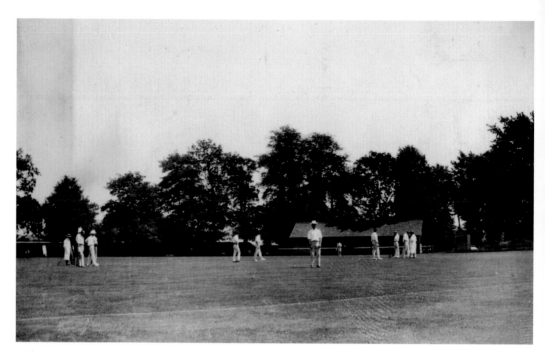

Witham Park Cricket Club

Cricket has been played in Witham since 1820 in what were the grounds of Witham House (now the HSBC bank). The first photograph was taken about 1900 and is therefore not the match of 'The Gentlemen of the Witham Club & The Australian Aborigines' (the first Australian Touring side) played on 14/15 September 1868! On 31 August 2009 Witham Cricket Club and Tauris Tourists played at the beginning of the 2009 Cricket Week.

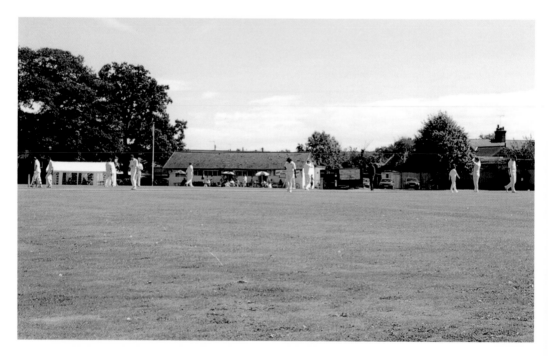

Saul's Bridge

Saul's Bridge over the River Brain in Maldon Road was built in 1814 and is the oldest iron bridge in Essex. After the early twentieth-century photograph was taken one side was extended to provide a footway and consequently the bridge lost its handrail. But apart from that, and a recent strengthening (hidden under the road surface), it remains remarkably intact but the area around it is decidedly less rural.

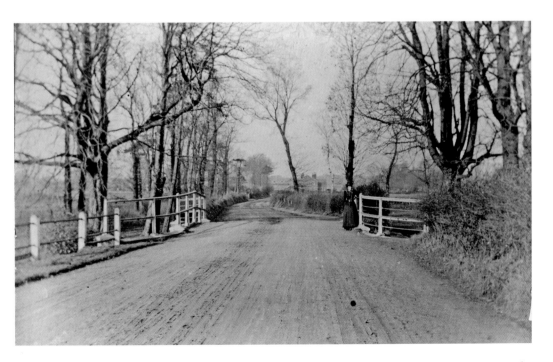

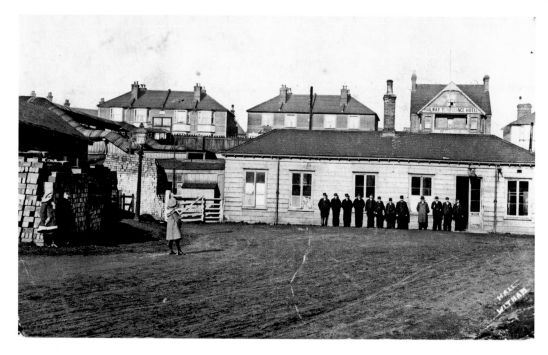

The Original Railway Station

The Eastern Counties Railway came to Witham in 1843 and built temporary timber buildings for the station. The wreck of the *Cromer Express* in 1905 provided the opportunity for a comprehensive rebuild. The booking office was moved to an overbridge adjoining Albert Road (see opposite) and the site of the original building eventually became the station car park. Beyond the station can be seen the Railway Temperance Hotel, now Witham House.

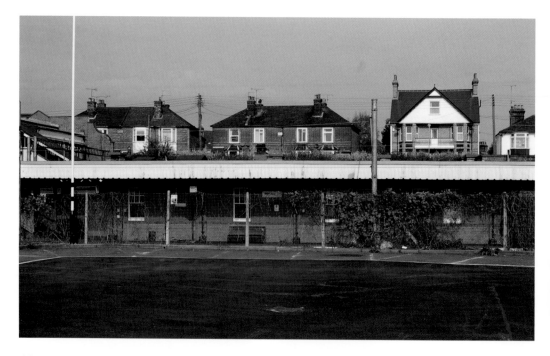

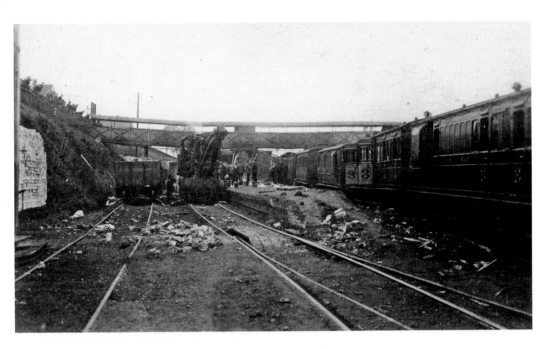

The Wreck of the *Cromer Express*

On 1 September 1905 the *Cromer Express* left the rails at Witham causing the loss of eleven lives. The photograph shows the clear-up operation well under way. This initiated a rebuilding of the station, the line has been electrified and the platforms have since been lengthened to accommodate twelve-car trains.

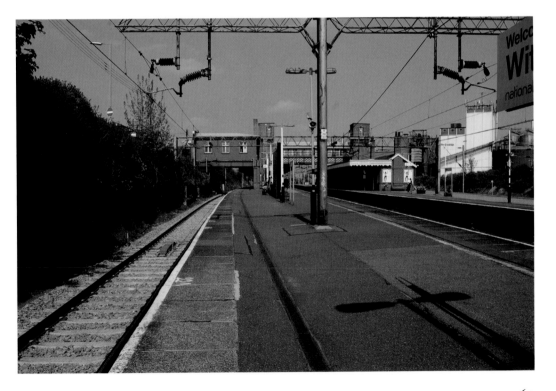

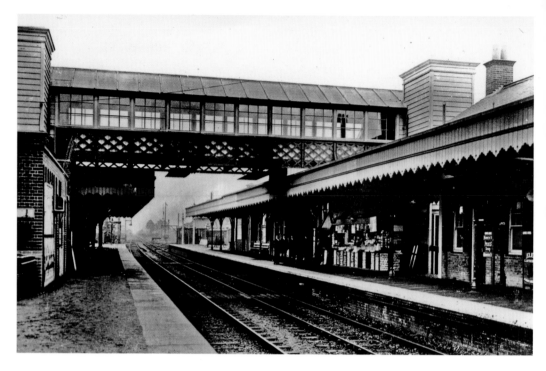

The Railway Station

The station has altered little since Great Eastern Railway days. The attractive old newspaper kiosk on platform 2 was replaced in 2009 by a modern structure for the sale of a variety of goods. New lifts in 1964 resulted in heightened lift shafts at either end of the footbridge.

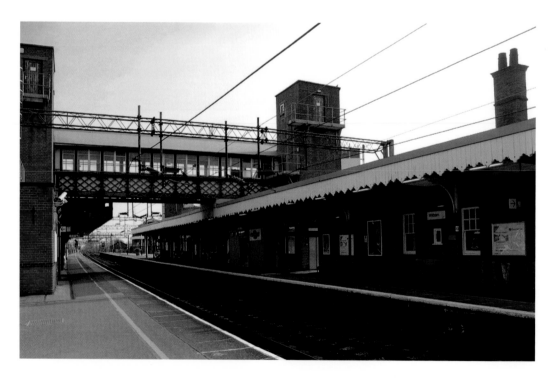

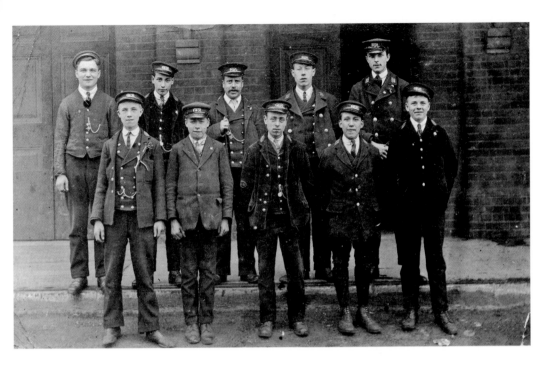

The People Who Run the Railway

This photograph was taken outside the booking office in Albert Road. The earlier picture dates from between 1907, when the booking office was built, and 1923, when it was still the Great Eastern Railway. Back row from second left: Ted Webb, Arthur Chalk, Albert Bright and A. Griggs. Front row from centre: Joe Birch and P. Thorogood on the end. The staff in 2009 include, from left: Lynn Turner, Patrina Murphy (station manager), Robb West, Angie Moran, Lou Grandini, Mick Gladwell and Bob Adams.

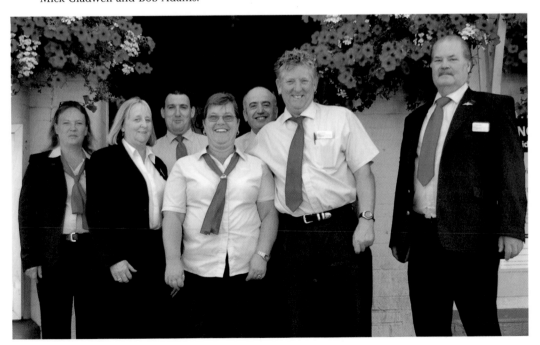

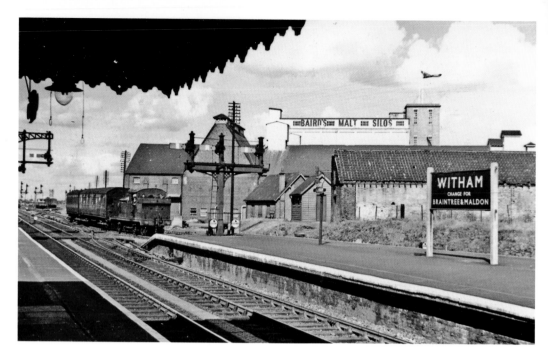

The Station Maltings from the Railway Station

The Witham plant is the largest of the Bairds malting sites with a total annual production of around 53,000 tonnes. The plant was originally established in 1926 when a 'traditional' floor maltings was built. Major investments in more recent years have seen the site being turned into one of the most modern in the country. In front, on 25 March 1956, the Maldon train approaches platform 4 while on 3 September 2009 a class 321 EMU arrives from London.

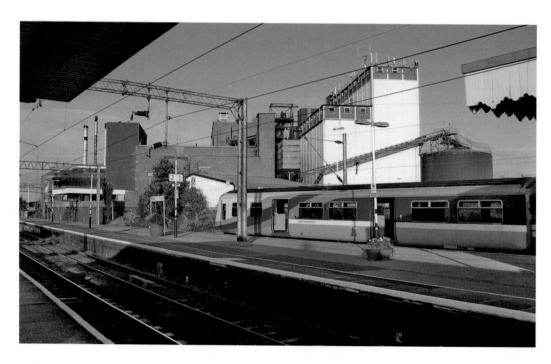

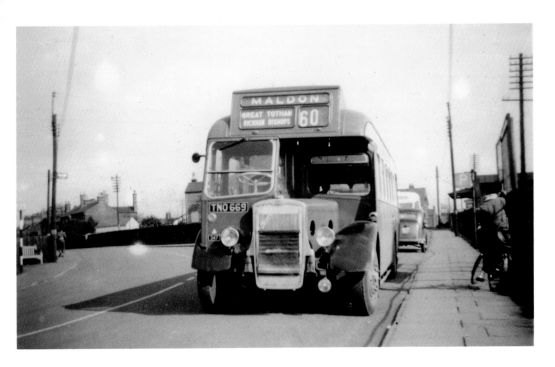

The Maldon Bus from the Railway Station

For those interested in buses this is a Bristol LWL5G, built 1951/2 with a E.C.W. B39r body on route 60 standing outside the station in about 1960, waiting for its driver. In 2009 a Blackwater Link bus departs from a bus shelter outside the station. This is a Dennis Dart with a Plaxton Pointer body on route 90. Albert Road has been made more bus friendly, and the old bus shelter has been converted into a coffee and refreshments bar.

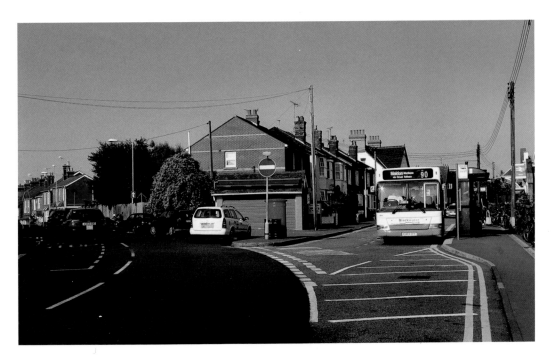

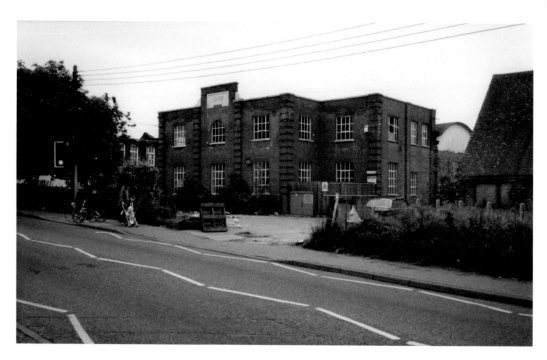

The Old Glove Factory

Coming from the town centre, the first property reached in Chipping Hill, opposite The Albert, was once Pinkham's National Glove Company. This factory, shown here soon before demolition in the 1980s, was cleared to provide for a small housing development known as Templemead. The factory was once a large employer but suffered from ladies' gloves going out of fashion in the later twentieth century.

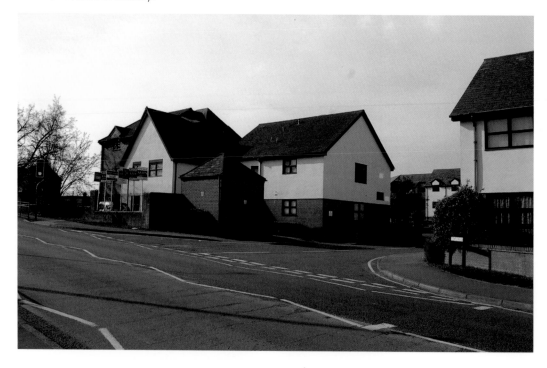

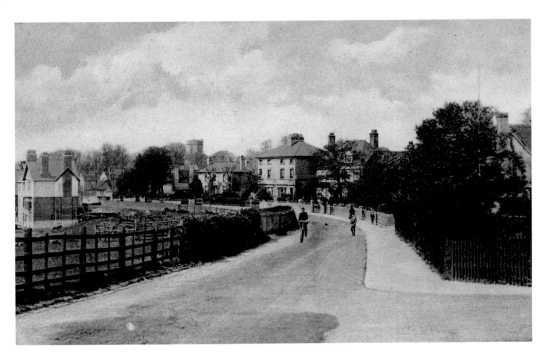

Chipping Hill from the Railway Bridge

With the Albert public house on the right, Chipping Hill drops down to the left towards the green and St Nicolas' church, just visible over the trees. The new road through to Braintree Road can be seen to the right, while Temple Villas to the left of the junction stand tall in both views. A small estate of the same name and a row of town houses have replaced Earlsmead, the large house to the left in the early view.

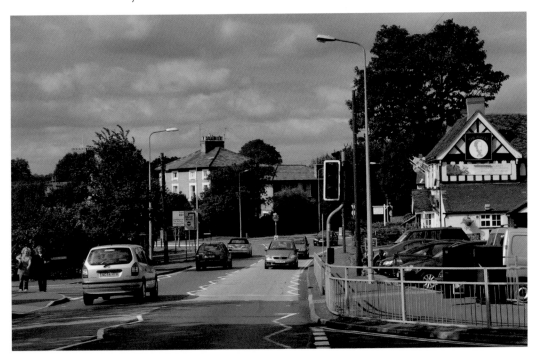

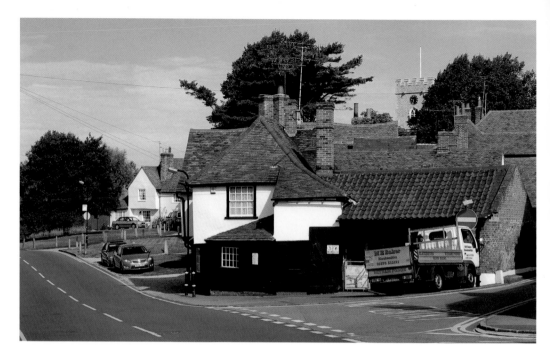

Chipping Hill Forge

Repairs and renovations by the County Council in 1979 showed the old forge to date from 1375 and it remains remarkably intact. It is still a blacksmith's workshop, as it has been for centuries, and is the subject of many a print or painting of picturesque scenes of Essex. The transport is different and a row of cottages on the green disappeared in the 1930s but little else has changed.

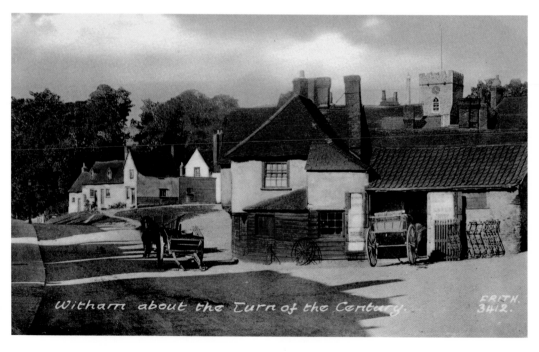

Witham about the Turn of the Century. FRITH. 3412.

Temples

The house known as The Temples, seen here soon after it was built in 1902, was demolished in 1969. Until 1971 Chipping Hill ran from the station bridge to the forge via a gentle left-hand curve. A new road curving round to the right was then built to relieve serious traffic congestion in the narrow part of Braintree Road. The Temples was the only house that had to be demolished.

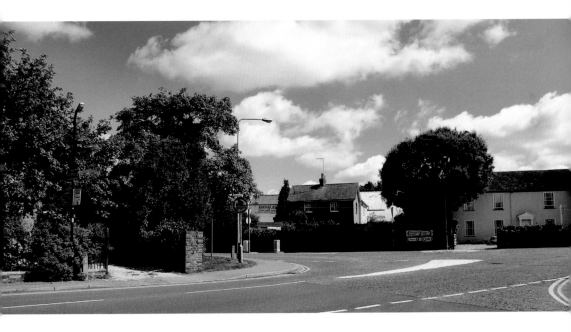

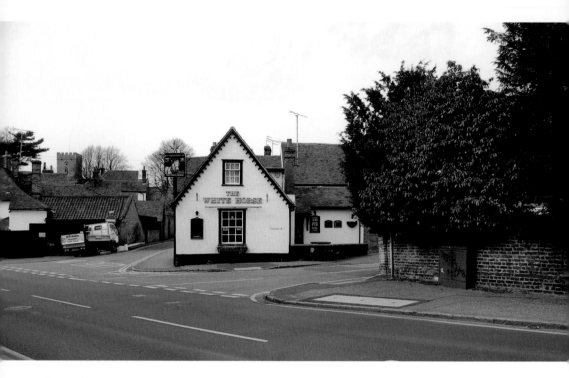

The White Horse

Sited on the same five-way junction as the forge, the White Horse exterior has changed little over the years apart from the entrance in White Horse Lane. The view from about 1900 shows the forge and buildings towards the church much as they are today. Even the highway has had few changes.

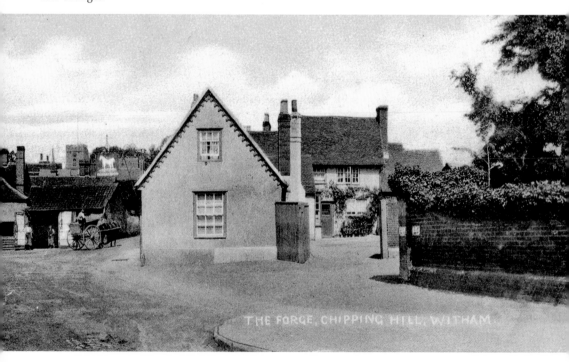

THE FORGE, CHIPPING HILL, WITHAM

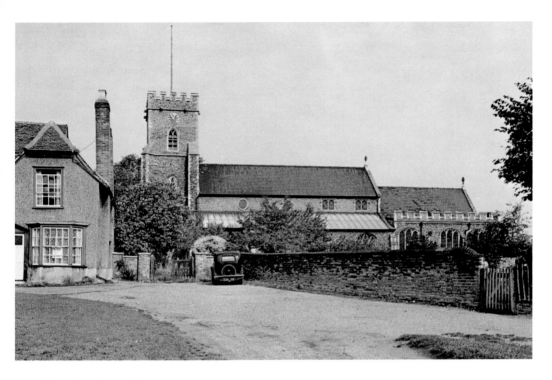

The Church and Green

St Nicolas' church seen from Chipping Hill Green. Trees have grown around the churchyard and the track to the church has been more clearly defined. Update the cars and decorate the cottage and the transformation is complete.

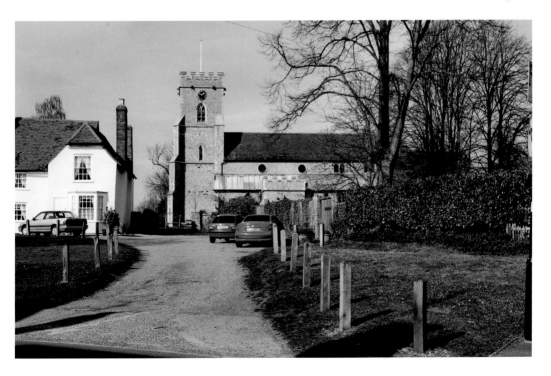

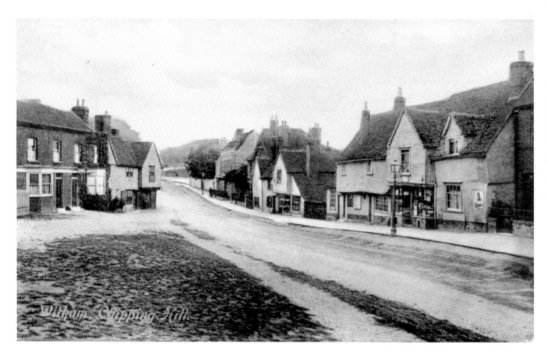

Looking Back Towards the Station From Chipping Hill Green

Chipping Hill was the original Saxon settlement until the Knights Templar built a new town on the Colchester Road in the thirteenth century. This view shows a number of medieval buildings that have survived. Only the building in the centre has been lost to a twentieth-century replacement. The earlier house had one of its wings converted into a shop, which was John Baron's sweet shop until 1936.

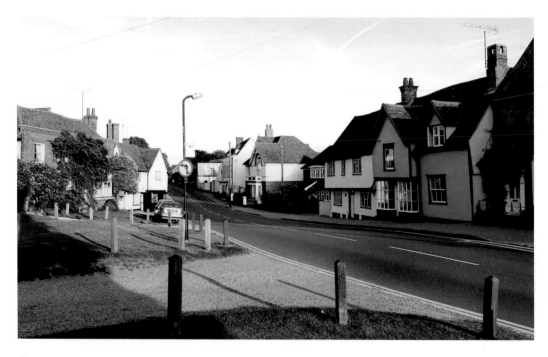

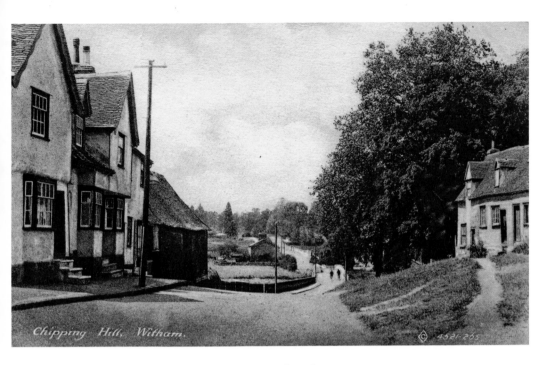

From Chipping Hill Green Towards Powers Hall End

On the left facing the green is a fifteenth-century house now known as the Old Manor House, with the tithe barn adjacent. The barn was demolished in 1928 and a modern house built in 1980 now replaces it. On the green to the right was a row of cottages. These were demolished in the 1930s when the track from the road to the church was laid out using the rubble from the demolition.

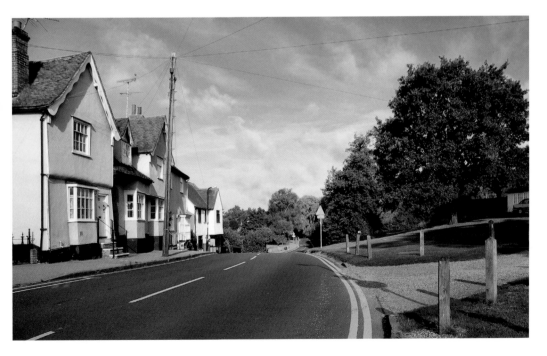

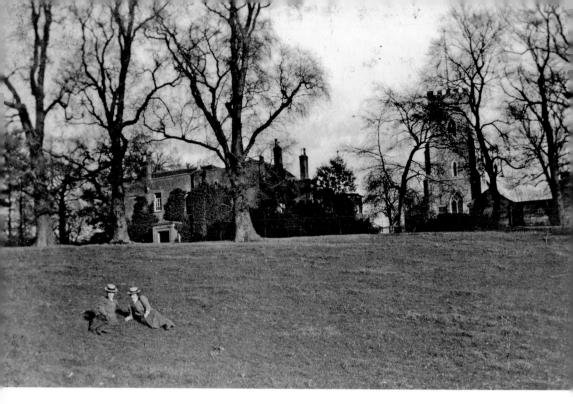

The Church and the Old Vicarage

In a winter view from about 1900 we see two figures in front of the vicarage and parish church. Canon Ingles was vicar at the time so these two ladies were likely to be members of his family. The house was reduced in size in the 1930s and sold into private ownership in 1976. Anne and Andrew Balfour, pictured, have lived there since 1989.

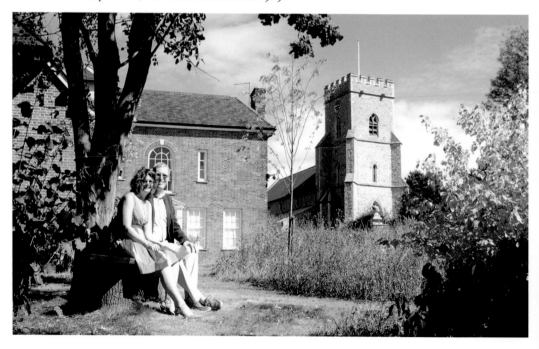

View from the Church Tower

Climbing up inside the church tower is a hazardous journey past the bells and on difficult ladders. In the original picture, taken at dusk, the railway viaduct can be seen clearly in the distance. At midsummer the present-day view shows mainly trees, the fields having been replaced by housing just visible through the trees

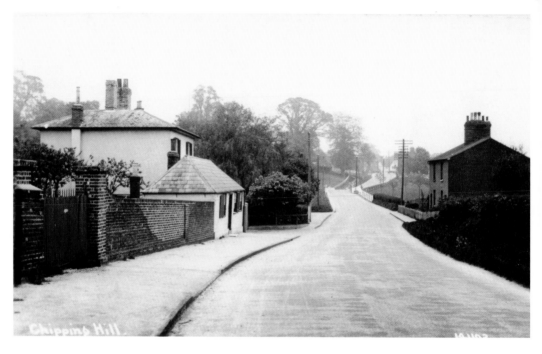

Spring Lodge and a View Towards Chipping Hill

Spring Lodge, a yellow Suffolk gault brick house, was built around 1840 for former farmer and miller Robert Bretnall. A part of the large estate of Witham Place, long since disappeared, Spring Lodge, seen on the left, has been offices but is now again a private residence. Further down the road is Chipping Hill Bridge over the River Brain where the land rises up to Chipping Hill Green.

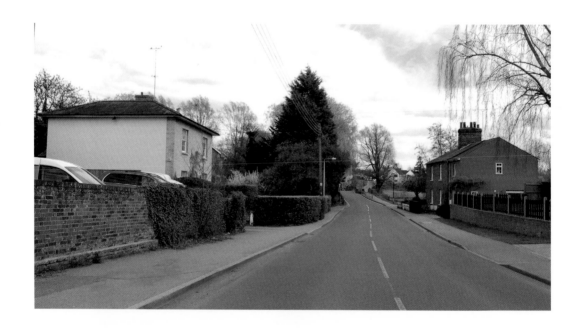

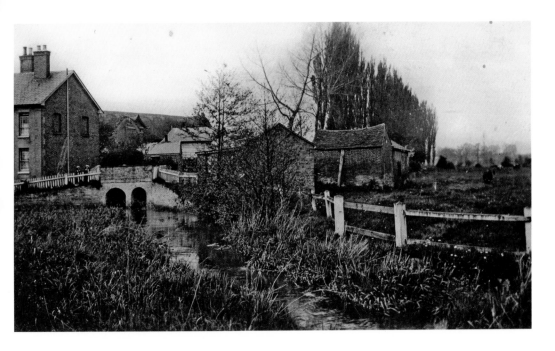

The Old Mill House

On the Powers Hall End side of the River Brain, by the bridge, stands the old Chipping Hill Mill and House. The house remains intact although heavily restored in 1992. The mill was burnt down in 1882 and the site remained empty for well over 100 years. In 2000 a house extension was constructed on the empty site designed to resemble the original mill. It is now a delightful family home.

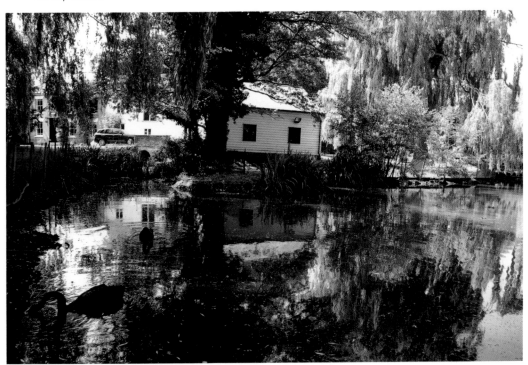

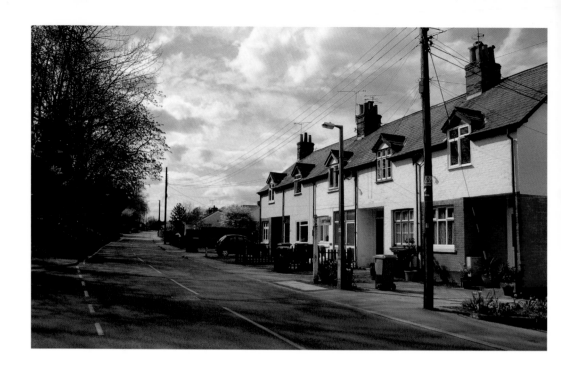

Powers Hall End

This row of cottages along Powers Hall End was originally photographed between the World Wars. The terrace has changed little since, but the medieval-looking building just the other side has gone and the front fence has been lost to car parking. The 'Maldon Iron Works' signpost shown in the current view cannot be as old as it looks!

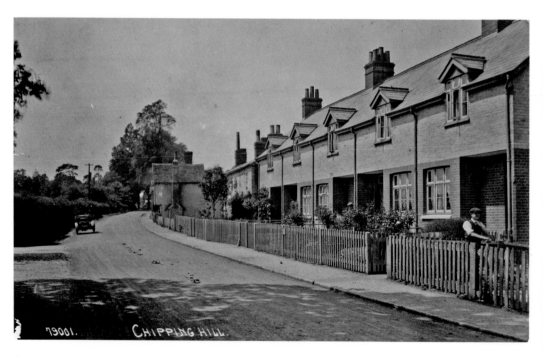

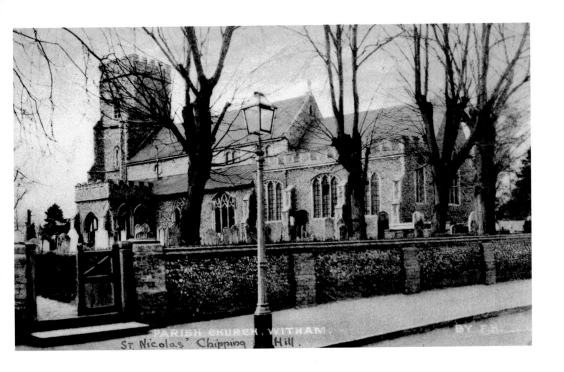

St Nicolas' Church

The two photographs of the fourteenth-century parish church, both taken in late winter, show how little things have changed here over the last century. Electricity has replaced gas for lighting, a gate has disappeared from the end of the wall and the inevitable double-yellow lines have appeared.

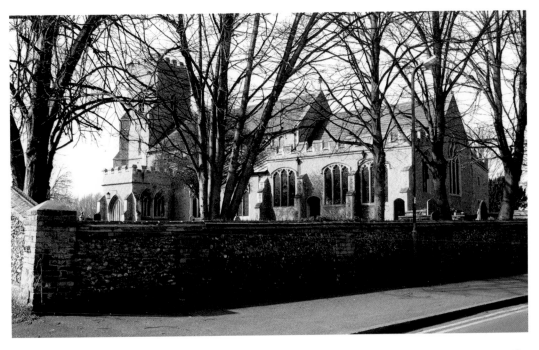

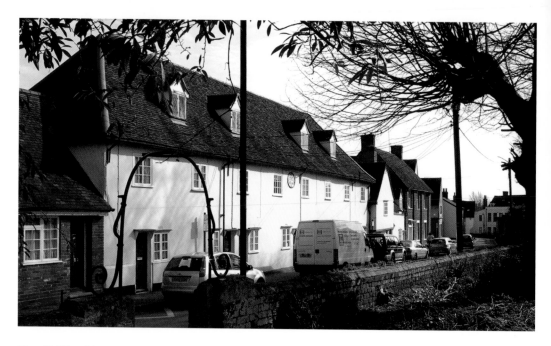

The Old Workhouse Cottages, Church Street

Numbers 28-40 Church Street were a workhouse from about 1714 to 1836 when a new building was completed in Hatfield Road. Now they are cottages let by Witham United Charities. This view towards Chipping Hill varies only over the years by the cart shed to the left being replaced by cottages and the loss of some cottages in the distance on the left-hand side, where shops were built in the 1950s.

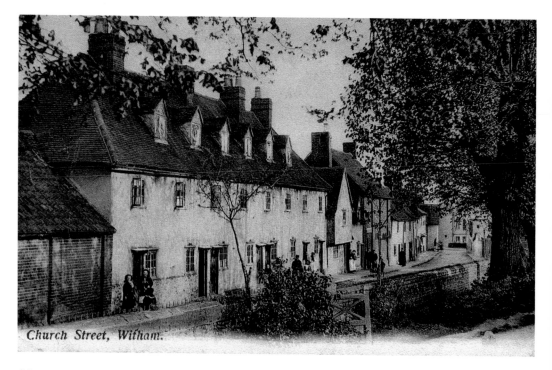

Church Street, Witham.

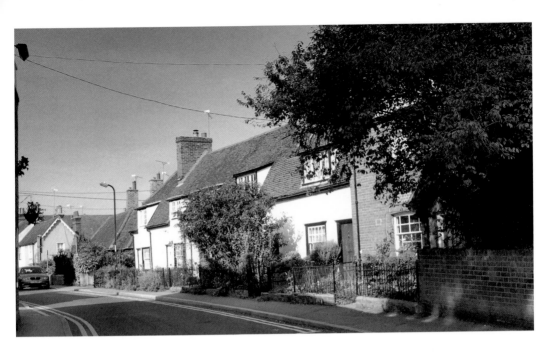

Church Street Towards Chalks Road

In this view of Church Street ivy has been replaced by shrubs and curious onlookers by cars and yellow lines. A pair of cottages on the right were once a shop. Frederick Hasler ran it as a grocery and general store from 1910 to 1930. William Pendle then took over until after the last war when he retired. It had a number of owners until 1989 when it was converted back into the two cottages seen in the later view.

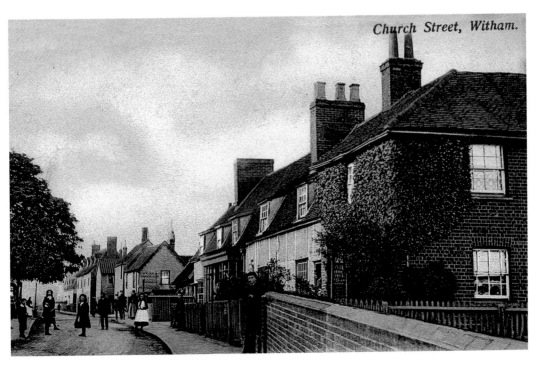

Church Street, Witham.

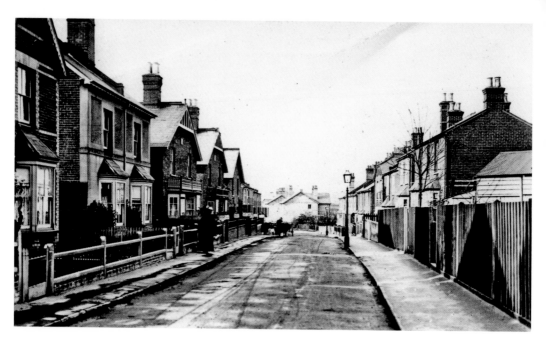

Braintree Road

Some time after the railway came through Witham, towards the end of the nineteenth century housing started to spread around the railway station. Braintree Road was built about that time and is typical of the period. The gas lamp has made way for electric lighting and the frontages have been cleared to provide car parking but the road is still recognisable today.

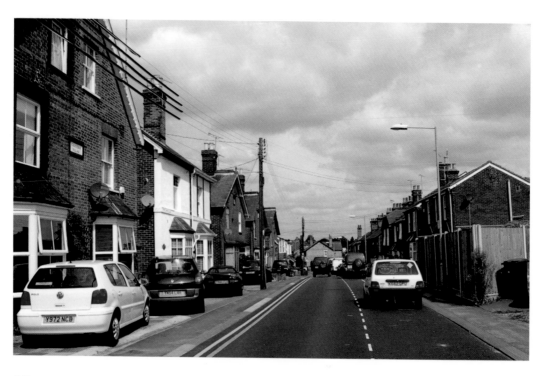

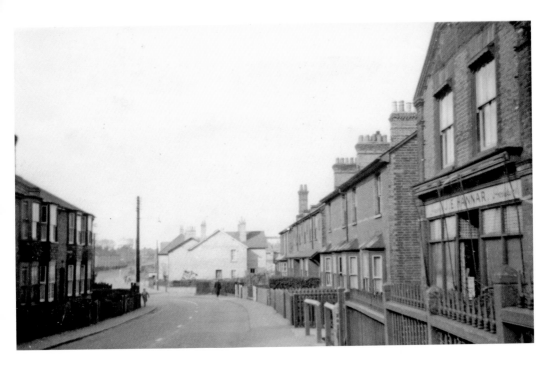

Braintree Road Shop

Another view of Braintree Road a little further down. The shop on the right, then J. E. Hannar Family Grocer & Provision Merchant, later became A. & D. K. Roberts, a stockist of Hurst Gunson Cooper Taber Ltd seeds, before being converted into residential accommodation. Apart from the bay windows and some modern cars the street has changed little over the years.

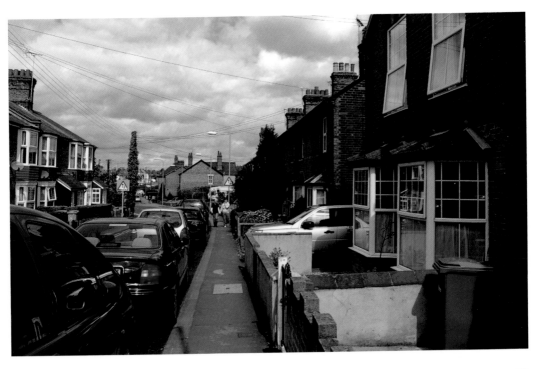

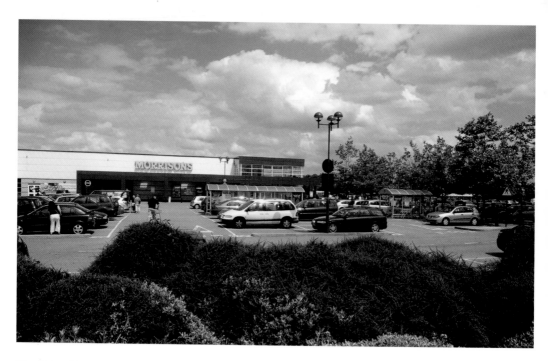

The Crittall Manufacturing Co.

In 1919 this factory was built in Braintree Road by the Crittall Manufacturing Company for the manufacture of steel office furniture and later produced the world-famous 'Crittall' metal window frames. Crittall's were a major employer in the town until a new factory was built in Braintree in 1990 and the Witham factory closed and, in 1992, was demolished. The site was redeveloped as a Safeway supermarket, now Morrisons. However, the Crittall Company has now returned to the town's industrial estate.

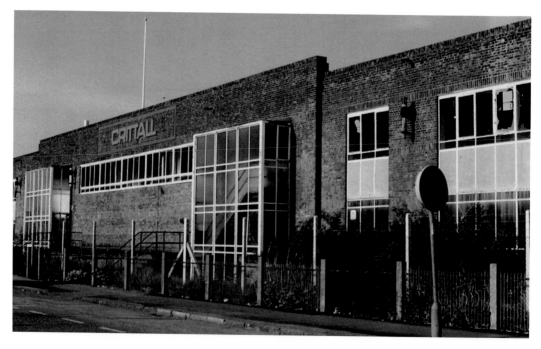

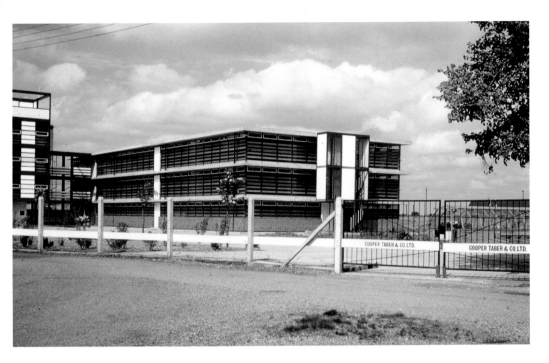

Even Some Modern Buildings Have Disappeared
This Modernist building for Hurst Gunson Cooper Taber Ltd seed merchants was built in
the 1960s and demolished in the 1990s. The new Atlantic Square office development has
taken its place.

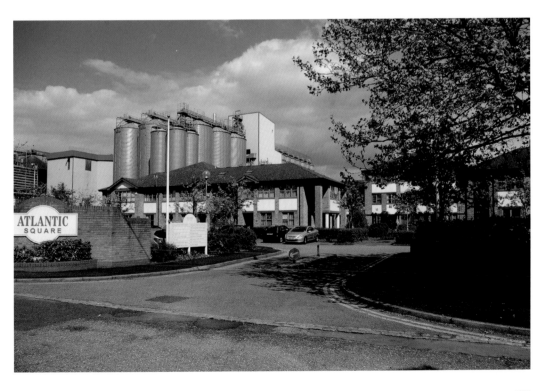

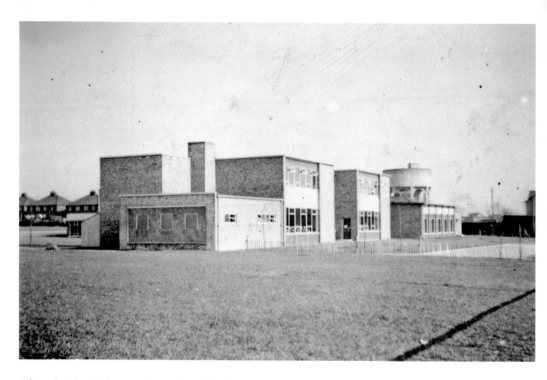

Education in Witham — Infant and Junior

The first picture shows Templars infant and junior schools in Cressing Road soon after they were built in the 1960s. Behind the school buildings can be seen the water tower of Cross Road which was demolished in the 1970s. In the second picture, taken in 2009, we see that grass and trees are now well established and that car parking has become prominent.

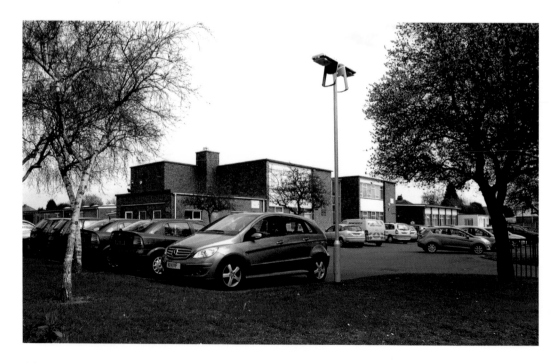

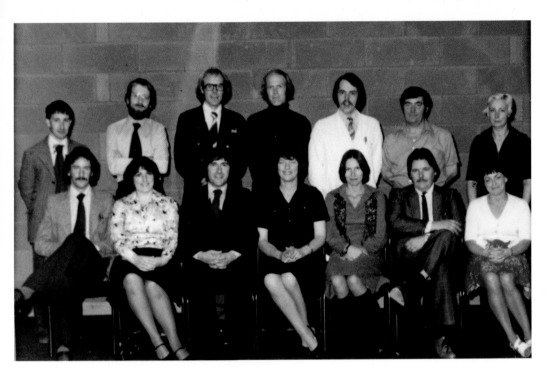

Secondary Education in Witham — Rickstones School

Staff at Rickstones School, which opened in 1977, (from left) back row from second: Terry Canty, Ken Jarvis, John Morris, Dr John Hudson. Front Row: David Triggs, Karel Gethin, Cyril Bridle, Norma Turner (head teacher), Sue Williams and Eric Pellika. On 1 September 2008 it became the New Rickstones Academy. Below is the Senior Leadership Team: Adie Howell, Sue Wright, Mike Eden, John Rooney, Dave Zeffie, Jon Gillard (principal), Bob Pulman, Claire Drane, Jerry Cross, Wendy Bower and Nick Long.

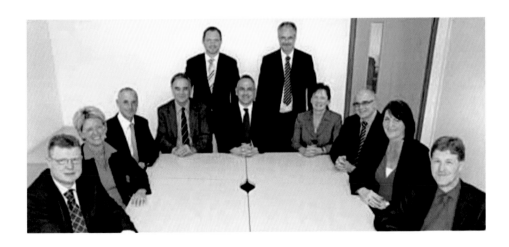

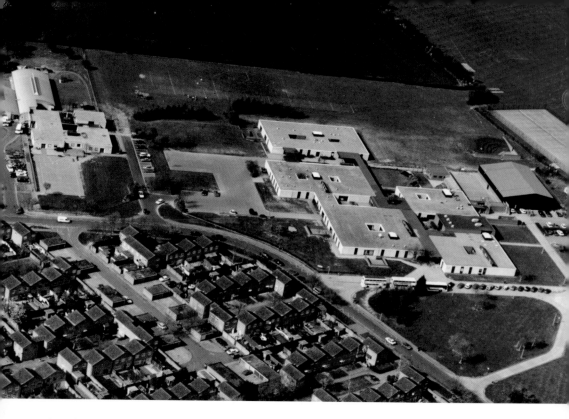

Education in Witham — Now for the Future
Rickstones School (see page 95) is seen here in an aerial view, beginning to show signs of age.
This will soon be demolished as a brand new school for the New Rickstones Academy is to be
built for future generations of Witham children.

Acknowledgements

The early photographs have been selected from the author's own collection of postcards,
but the use of postcards and photographs from other sources is greatly appreciated. These
include the photographic collections of Cyril Taylor, Lester Shelley, John Scott-Mason, the
Essex Police Museum, Dr Lee's family, Hilda Ely, M. Morarji, M. Stanton, Terry Hutton,
New Rickstones Academy, the Witham & Countryside Society and Witham Town
Council. Thanks are due also to John Page for his help with the Essex Police Museum
pictures. Other images came from Ernest Joyce & Co. Ltd and Harold D. Bowtell.

Thanks also to Cyril Taylor whose records of Witham businesses were invaluable
and to the late Maurice Smith who made his research available to the society. Also
Alan Osborne (Essex Bus Enthusiasts Group) for his help with bus identities and Janet
Gyford, as I am sure some of our records from various sources could have come from
her originally. Thanks also to Sylvia Saunders who generously gave her time to help with
the captions and proofs.

All new photographs are by the author except that of New Rickstones Academy
Senior Leadership Team (New Rickstones Academy).